BLACKBOARD SKETCHING

By
FREDERICK WHITNEY
Director *of* Art, State Normal
School, Salem, Massachusetts

Copyright © 2013 Read Books Ltd.
This book is copyright and may not be
reproduced or copied in any way without
the express permission of the publisher in writing

British Library Cataloguing-in-Publication Data
A catalogue record for this book is available from the
British Library

Drawing and Illustration

Drawing is a form of visual art that can make use of any number of drawing instruments, including graphite pencils, pen and ink, inked brushes, wax colour pencils, crayons, charcoal, chalk, pastels and various kinds of erasers, markers, styluses, metals (such as silverpoint) and even electronic drawing. As a medium, it has been one of the most popular and fundamental means of public expression throughout human history – as one of the simplest and most efficient means of communicating visual ideas.

Drawing itself long predates other forms of human communication, with evidence for its existence preceding that of the written word – demonstrated in cave paintings of around 40,000 years ago. These drawings, known as pictograms, depicted objects and abstract concepts including animals, human hands and generalised patterns. Over time, these sketches and paintings were stylised and simplified, leading to the development of the written language as we know it today. This form of drawing can truly be considered art in its purest sense – the basic forms on which all others build.

Whilst the term 'to draw' derives from the Old English *dragan* (meaning 'to drag, draw or protract'), the word 'illustrate' derives from the Latin word *illustratio,* meaning 'enlighten' or 'irradiate'. This process of 'enlightenment' is central to drawing and illustration as we know it today. Medieval codices' illustrations were often called 'illuminations', designed to highlight and further explain

important aspects of biblical texts. This was the most general form of illustration; hand-created, individual and unique. This changed in the fifteenth century however, when books began to be illustrated with woodcuts – most notably in Germany, by Albrecht Dürer.

The first creative impulses of a painter or sculptor are commonly expressed in drawings, and architects and photographers are commonly trained to draw, if for no other reason than to train their perceptual skills and develop their creative potential. Initially, artists used and re-used wooden tablets for the production of their drawings, however following the widespread availability of paper in the fourteenth century, the use of drawing in the arts increased. During the Renaissance (a period of massive flourishing of human intellectual endeavours and creativity), drawings exhibiting realistic and representational qualities emerged. Notable draftsmen included Leonardo da Vinci, Michelangelo and Raphael. They were inspired by the concurrent developments in geometry and philosophy, exhibiting a true synthesis of these branches – a combination somewhat lost in the modern day.

Figure drawing became a recognised subsection of artistic drawing in this period, despite its long history stretching back to prehistoric descriptions. An anecdote by the Roman author and philosopher Pliny, describes how Zeuxis (a painter who flourished during the 5th century BCE) reviewed the young women of Agrigentum naked before selecting five whose features he would combine in order to paint an ideal image. The use of nude models in the medieval artist's workshop is further implied in the writings

of Cennino Cennini (an Italian painter), and a manuscript of Villard de Honnecourt confirms that sketching from life was an established practice by the thirteenth century. The Carracci, who opened their *Accademia degli Incamminati* (one of the first art academies in Italy) in Bologna in the 1580s, set the pattern for later art schools by making life drawing the central discipline. The course of training began with the copying of engravings, then proceeded to drawing from plaster casts, after which the students were trained in drawing from the live model.

The main processes for reproduction of drawings and illustrations in the sixteenth and seventeenth centuries were engraving and etching, and by the end of the eighteenth century, lithography (a method of printing originally based on the immiscibility of oil and water) allowed even better illustrations to be reproduced. In the later seventeenth and eighteenth centuries, the previous combination of the arts and sciences in drawing gave way to a more romantic and even classical style, epitomised by draftsmen such as Poussin, Rembrandt, Rubens, Tiepolo and Antoine Watteau. Mastery in drawing was considered a prerequisite to painting, and students in Jacques-Louis David's Studio (a famed eighteenth century French painter of the neo-classical style), were required to draw for six hours a day, from a model who remained in the same pose for an entire week!

During this period, an increasingly large gap started to emerge between 'fine artists' on the one hand, and 'draftsmen' / 'illustrators' on the other. This difference became further complicated with the 'Golden Age of Illustration'; a period customarily defined as lasting from the

latter quarter of the nineteenth century until just after the First World War. In this period of no more than fifty years the popularity, abundance and most importantly the unprecedented upsurge in quality of illustrated works marked an astounding change in the way that publishers, artists and the general public came to view artistic drawing. Arthur Rackham, Walter Crane, John Tenniel and William Blake are some of its most famous names. Until the latter part of the nineteenth century, the work of illustrators was largely proffered anonymously, and in England it was only after Thomas Bewick's pioneering technical advances in wood engraving that it became common to acknowledge the artistic and technical expertise of illustrators. Such draftsmen also frequently used their drawings in preparation for paintings, further obfuscating the distinction between drawing/painting, high/low art.

The artists involved in the Arts and Crafts Movement (with a strong emphasis on stylised drawing, and a powerful influence on the 'Golden Age of Illustration') also attempted to counter the ever intruding Industrial Revolution, by bringing the values of beautiful and inventive craftsmanship back into the sphere of everyday life. This helped to counter the main challenge which emerged around this time – photography. The invention of the first widely available form of photography (with flexible photographic film role marketed in 1885) led to a shift in the use of drawing in the arts. This new technology took over from drawing as a superior method of accurately representing the visual world, and many artists abandoned their painstaking drawing practices. As a result of these developments however, modernism in the arts emerged – encouraging 'imaginative

originality' in drawing and abstract formulations. Drawing was once again at the forefront of the arts.

There are many different categories of drawing, including figure drawing, cartooning, doodling and shading. There are also many drawing methods, such as line drawing, stippling, shading, hatching, crosshatching, creating textures and tracing – and the artist must be aware of complex problems such as form, proportion and perspective (portrayed in either linear methods, or depth through tone and texture). Today, there are also many computer-aided drawing tools, which are utilised in design, architecture, engineering, as well as the fine arts. It is often exploratory, with considerable emphasis on observation, problem-solving and composition, and as such, remains an unceasingly useful tool in the artists repertoire.

The processes of drawing is a fascinating artistic practice, enabling a beautiful array of effects and creative expression. As is evident from this short introduction, it also has an incredibly old history, moving from decorations on cave walls to the most advanced, realistic and imaginative drawings possible in the present day. It is hoped that the current reader enjoys this book on the subject.

Introduction

ABILITY to draw easily and well on the blackboard is a power which every teacher of children covets. Such drawing is a language which never fai's to hold attention and awaken delighted interest.

It has been considered impossible for most of us, because we have never done it. It has been strongly recommended, but no one has really shown us how.

A book like this which does show how, step by step, from the first practice strokes to completed and effective sketches, will be everywhere welcome. No one can follow the plain suggestions given without appreciating the possibilities of chalk and charcoal for ordinary school-room illustration, and finding in himself a steady development of power to sketch on the blackboard.

The book is not the product of theories about drawing, but the fruit of long experience of one who has drawn with and for children and students and teachers, and has been more successful than any one I know in inspiring them by that means. I welcome the book and predict for it a potent influence for increasing and improving blackboard drawing throughout the schools of the land.

WALTER SARGENT.

North Scituate, Mass.

Author's Introduction

This collection of blackboard sketches and the accompanying text has been planned at the request of many teachers and pupils who desire lessons and suggestions along this line, but who are unable to secure personal instruction.

In general, these requests have been for simple sketches dealing with the various lines of school work, and at the same time for strokes and explicit directions for using these in the drawings. For these reasons there are given upon nearly every plate the strokes of the chalk useful in producing the desired effect, and upon the opposite page such directions as are generally given to the students in the classroom.

A few of the lessons deal with the strokes and their application to the very simplest objects possible, but even these may be found useful as illustrative material. They are recommended in order that the teacher may become familiar with the medium, and with the simplest and the most direct manner of handling it before attempting sketches which require a great variety of touches. I have tried to have the other sketches cover as great a variety of subjects as possible.

Plates 3, 5, 8, 10, 11, 13, 14, 15, 16, 17, 18, 22, 23 and 29 have been used with the little people in different forms of stories, language and reading lessons. Plates 7, 8, 9, 10, 11, 18, 27, 28 and 29 are suggested for geography lessons in various grades. Plates 8, 14, 15, 16, 17, 18, 27, 28 and 29 may be used in history lessons. Plates 1 and 3 have been used in primary numbers, and plates 27 and 28 for arithmetic, when the problems had to do with commission, measurement, etc., or when the problems referred to lumbering or manufacturing. Plates 4, 5, 6, 11, 12, 13, 19, 20, 21, 22, 23, 24, 25, 27 and 28 will be found helpful in many lines of nature study, especially when the nature specimens are difficult to obtain. Plates 9, 24, 25 and 26

illustrate the value of this line of drawing in the study of literature; and many of the other drawings may be used in a similar manner. The teacher who uses this type of illustrative sketching will readily see how the drawings may be applied to other subjects.

Teachers have occasionally asked for illustrations for the different months of the school year, something to use with calendars, or for different holiday drawings. Several sketches given on the plates are suitable for the various months. For calendars I suggest discarding the plaided pumpkin for November, the numbered bricks in a fireplace for December, the kite covered with numbered squares for March, etc., etc. A regular numbered calendar may be used, with an appropriate sketch above or at one side. See Plate 13, goldenrod. The holiday itself should suggest the character of the sketch.

Although these sketches are recommended as illustrations for certain subjects, it is not intended that the teacher should merely copy these drawings, but that she should be able to appropriate these strokes, enlarge upon them, and apply them in illustrations for the particular subjects she is teaching; and there are many subjects which require just this sort of expression on the part of the teacher.

"Children are not all ears; they take in more through the eyes than in any other way."

Since all teachers know this is true, they should realize the usefulness of illustration on the blackboard.

A few moments now and then devoted to the practice of these strokes, and frequent application of them, will enable the teacher better to express and emphasize certain facts, details, or incidents connected with a lesson; better to hold the interest and attention of the class, and more readily to create an interest in drawing. She will thus, by example, lead the children to make the drawing a natural and spontaneous means of expression.

FREDERICK WHITNEY.

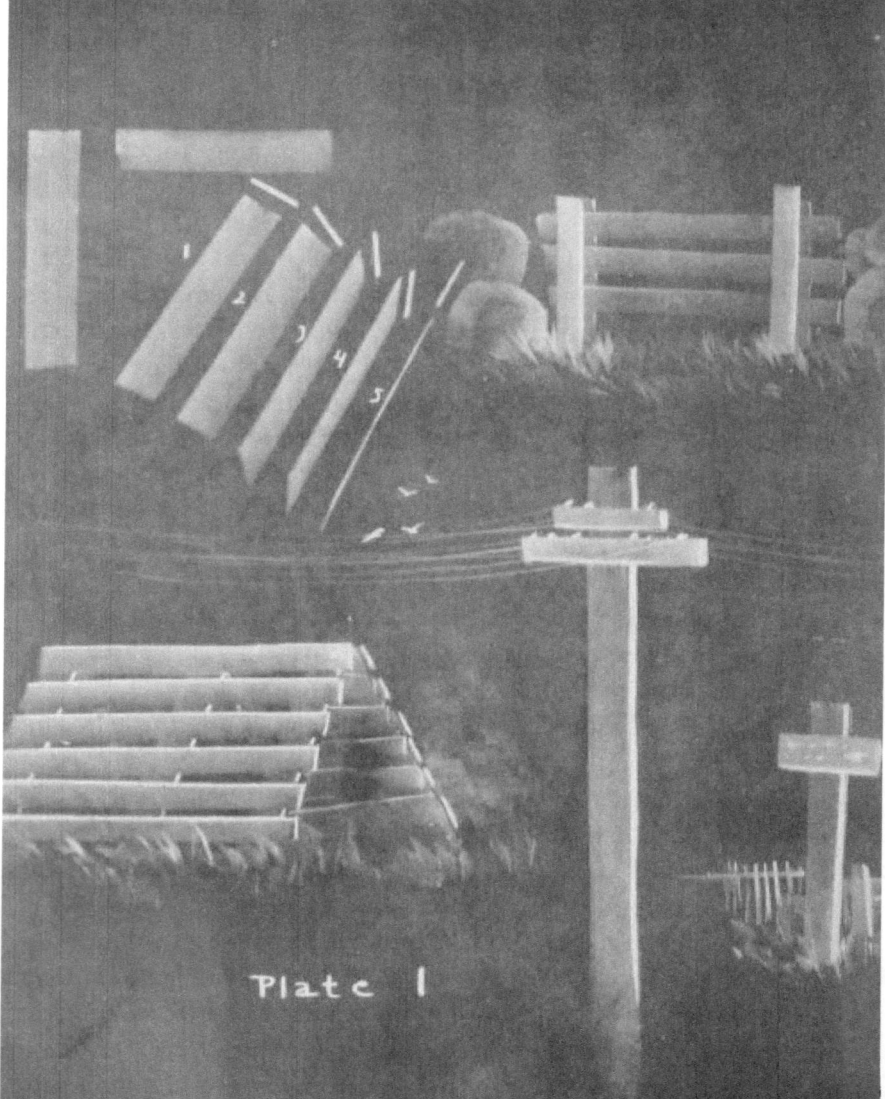

Plate 1

PLATE 1

For the first lesson I advise trying the simplest possible stroke, and its application in the sketching of very simple things. The stroke is a straight mark with the side of the chalk.

Take half or two-thirds of a stick of chalk, discard the small end, and use such a piece in nearly all the lessons given. In this case place the chalk horizontally upon the board, and drag it gradually downward, keeping an even pressure upon the chalk. Try this in various directions.

The oblique lines show what a variety of width may be obtained by changing the angle of the chalk. At 1, the full length of the chalk is required to give the broad stroke desired. At Nos. 2, 3, 4 and 5, the line above the stroke indicates the angle at which the chalk is placed in order to give the width of the strokes below. The use of the chalk in this manner enables one to obtain any desired width of line, without constantly changing the piece of chalk. A light or dark tone is produced by varying the pressure upon the chalk.

In drawing the telegraph pole, draw first a delicate vertical stroke, then add the horizontal cross pieces with a stronger accent, and last the white strokes indicating thickness.

In the case of the chicken coop, draw first the oblique slats, then with a stronger pressure upon the chalk, add the horizontal slats, and lastly, with the point of the chalk add the accented bits of detail.

Almost any simple object composed of straight lines may be drawn in this manner.

Plate 2

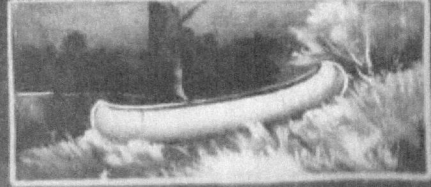

PLATE 2

The strokes upon this plate are more often used than any others which will be given in these lessons. These strokes are made by holding the chalk by one end rather than in the middle, and then by drawing in any direction desired, letting the pressure come at the end of the chalk, thus giving a graded stroke from side to side. For example, stroke 1 was made by taking about two-thirds of a stick of chalk, holding it by the left end, placing it horizontally upon the board, and then drawing downward, accenting a little with the left end of the chalk. Stroke 5 was made in a similar manner, the chalk being held by the right end, and the pressure being also at that end.

Practice these strokes in many directions, and then apply them to drawing some simple objects. On the plate the cylinder, barrel, and canoe are illustrated to show the application of such simple marks.

In the cylinder, strokes 1 and 5 are used for the left and right outlines; then three curving strokes will finish the top and bottom.

In sketching the barrel, use similar strokes, curving them a bit. Add curving strokes for the hoops, using a short piece of chalk; then add markings here and there with the point for details.

The canoe is one long, nearly horizontal stroke accented at the upper end of the chalk. A few small touches similar to those at 3 will give the rocky shore, and a line or two with the point, the necessary details.

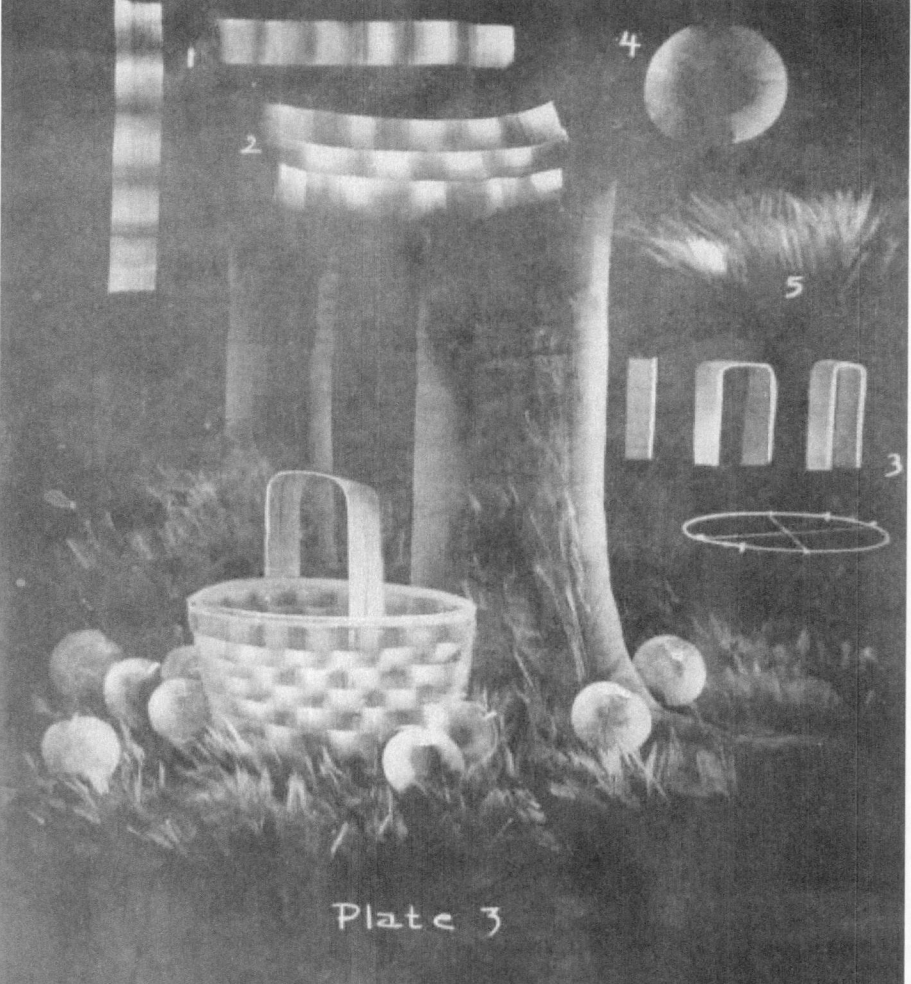

Plate 3

PLATE 3

The lesson planned at illustration 3 is useful in a number of school lessons in the lower grades. I have seen it used in teaching reading in the first grade. In this case, some word from the lesson was written upon each apple, and the children were asked to see how many apples they could gather and put into the basket; in other words, to see how many words they could read. When a word was recognized, it was erased. Again, it has been successfully used in teaching number, form, etc. See also the ladder, plate 10.

Stroke 1 is made by placing the chalk upon the board in a vertical position and then drawing it across the board, varying the pressure frequently so as to give the effect seen in the basket. The strokes at 2 are produced in the same manner. Here the light spots in the stroke are alternated, coming beneath the dark spots in the stroke above. Try a number of these in the curving direction suggested at 2.

In making a sketch of a basket, draw lightly the elliptical top, then add as many strokes as are necessary to give the desired depth, and lastly add the handle. Strokes 3, and the ellipse below them, show the manner of producing this effect. Place the chalk horizontally at the top of the basket, decide where the handle should end at the opposite side, then draw upward with a heavy stroke, across the top lightly, then downward with a slight pressure. Keep the chalk in a horizontal position throughout the stroke. Add a line of accent to the nearest edge of the handle.

The tree trunk back of the basket is drawn with strokes 1 and 5, plate 2, the stroke being curved a bit at the lower end. The grass is added by the use of stroke 5, which is made by using a short piece of chalk, and by moving the hand rapidly up and down. A little accent may be used occasionally.

In drawing the apples study stroke 4. These are made like those on plate 2, by accenting with the end of the chalk. Use a very short curving stroke, first toward the left, then toward the right. Add stems, etc., with the point of the chalk.

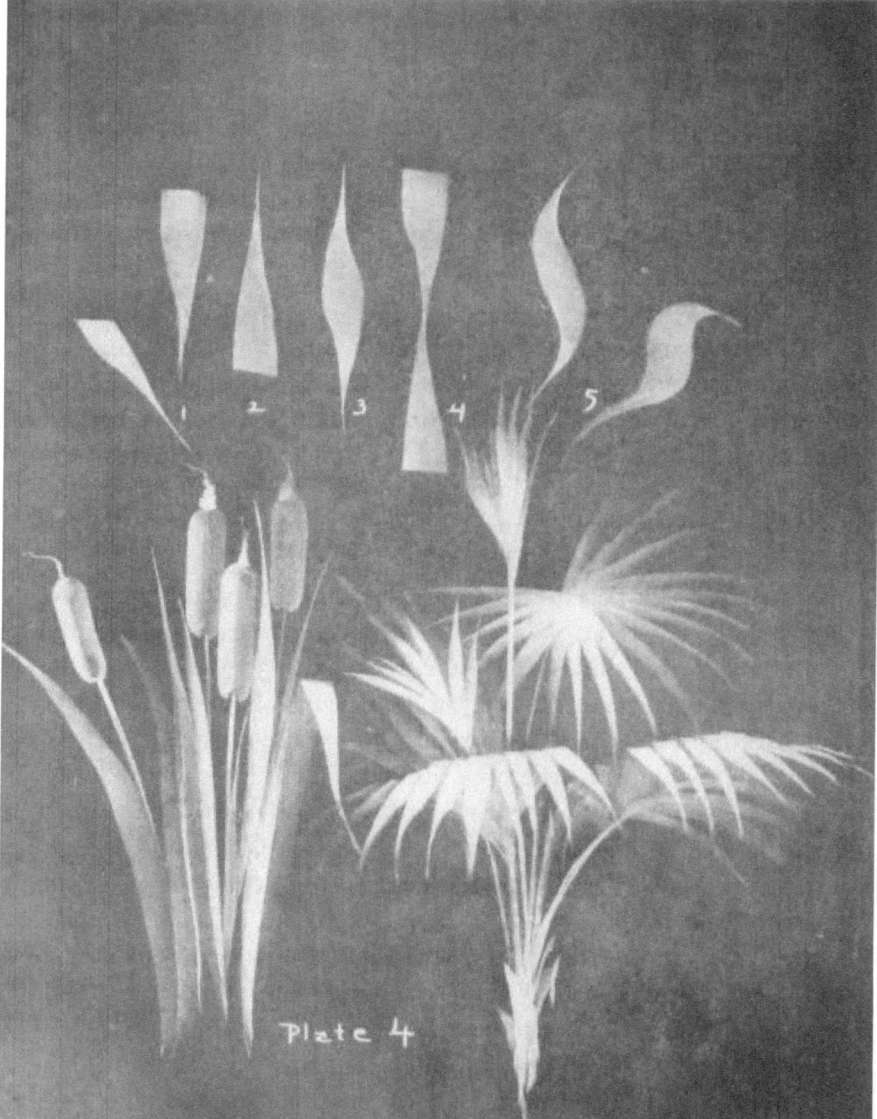

PLATE 4

Lesson 4 introduces a stroke entirely different from those already given, and one which will require more practice in order to obtain the desired results and to apply it readily in quick sketches.

Stroke 1 is made by placing the chalk in a horizontal position upon the board, and drawing it downward, gradually twisting it to the vertical position. Stroke 2 is the exact opposite. Place the chalk vertically upon the board, draw it downward and gradually twist it to the horizontal position.

In drawing strokes 3 and 4, combine those already given at 1 and 2. For 3, place the chalk vertically, draw it downward, quickly twisting it to the horizontal position; then, without removing it from the board, bring it back to the vertical position. Try stroke 4, beginning with the horizontal position of the chalk, twisting it to the vertical, then back again to the horizontal position.

Stroke 5 shows a curving effect produced in the same manner as stroke 3, but with a curving instead of a vertical tendency.

In drawing the cat tails, use strokes 1 and 5 on plate 2. These are slightly curved at the upper and lower ends. Keep some of them very delicate, others quite white. The leaves are drawn by using strokes 1, 2, and 3, on plate 4. Let the tone desired in the drawing govern the pressure used upon the chalk.

The palms are drawn by using the same strokes. Draw first very delicately with the side of the chalk, then with strokes 1, 2 or 3 add stronger strokes for accent.

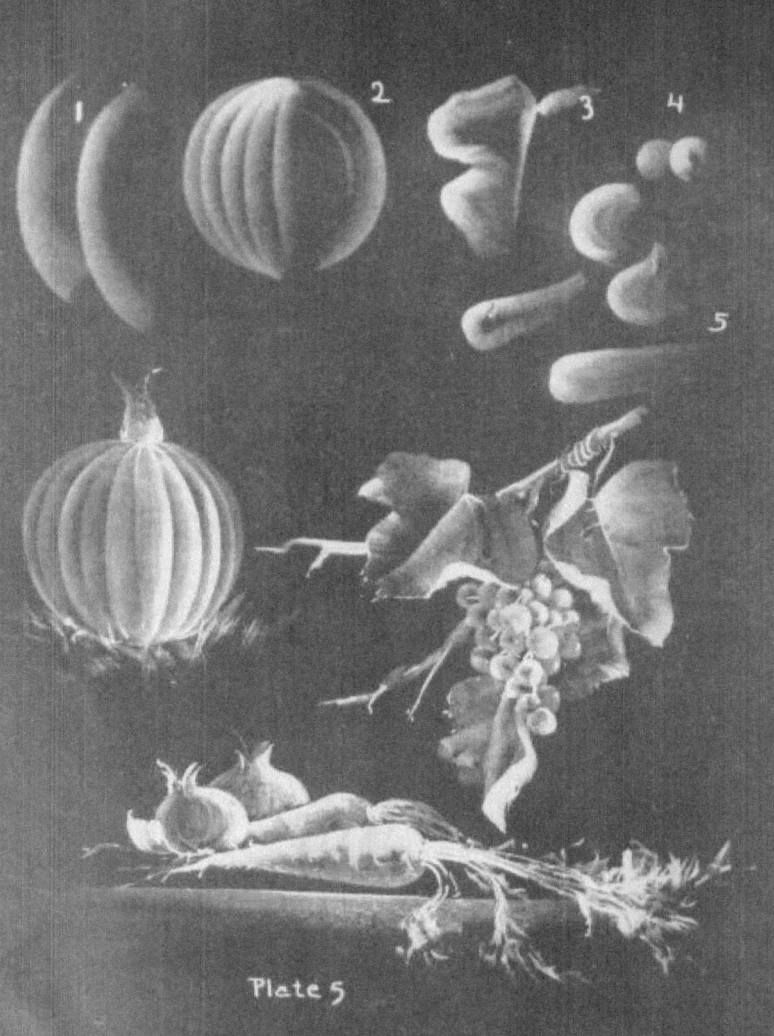

Plate 5

PLATE 5

A new stroke will be introduced for this lesson. It is a regular or irregular curve as the case may require, and is useful in all sorts of nature drawing.

First try the long curving stroke No. 1, accenting with the left end of the chalk. Reverse the stroke, accenting with the right end of the chalk. Now try No. 2, making a series of nearly parallel strokes, keeping the accent at the left.

The pumpkin is drawn by combining these strokes, varying the pressure to obtain the desired tone, and accenting with the left end of the chalk, then reversing the stroke for the right side of the pumpkin. Add the stem by the use of a few irregular strokes and a bit of accent.

Stroke 3 may be used in drawing any large leaves, such as squash, grape, etc. Try this in a great variety of positions, always keeping the accent for the edge of the leaf. Apply this in drawing the grape foliage in the illustration below. Draw first the mid-rib and then represent the surface of the leaf by using stroke 3. The grapes are added by the use of stroke 4, which is stroke 1 very much reduced. Let the grapes be drawn with a short, quick twist of the chalk. Lastly add stems and accent.

Almost any vegetables may be drawn after a little practice of the strokes given at 5. These are made exactly like stroke 1, with changes in direction. Try a single onion or carrot, then a group of vegetables. Do these as simply as possible, obtaining the effect, if you can, with three or four strokes, then add a few touches for details.

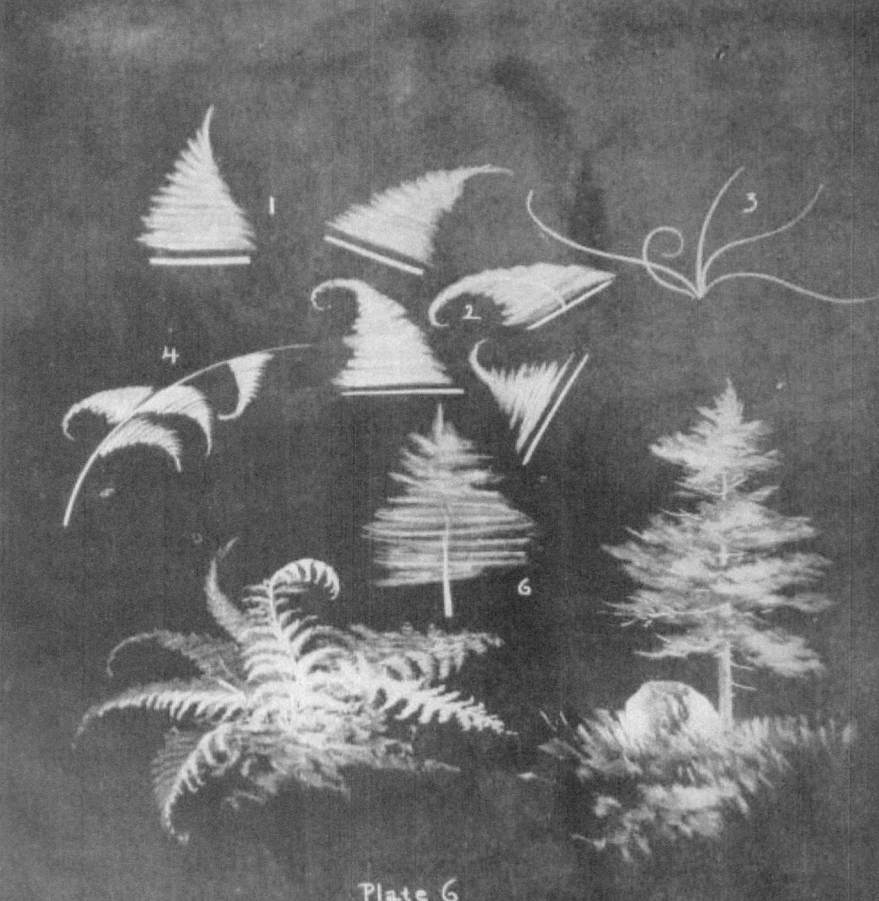

Plate 6

PLATE 6

The strokes given in this lesson, although not used as frequently as those previously given, are nevertheless valuable.

No. 1 shows the manner in which the stroke is produced. Place a piece of chalk in the position indicated by the line below the stroke, then swing the chalk rapidly back and forth, shortening the stroke and gradually twisting the chalk to the vertical position. No 2 is produced in the same manner. Place the chalk obliquely as indicated, and keep the movement oblique, shortening the stroke, and twisting the chalk gradually to the horizontal position.

The fern is drawn by first sketching a few main lines, No. 3, and then upon these apply the strokes given as shown at No. 4. Hardly touch the board at first, keeping the tones very gray; then add a few white ferns as in the sketch.

No. 6 illustrates the same stroke used in a much bolder fashion and in a generally horizontal direction. After applying this stroke, accent here and there with a much shorter stroke, and add the trunk and branches.

Study the trees given on plate 12 in connection with this illustration and notice the variety of strokes given for the different trees.

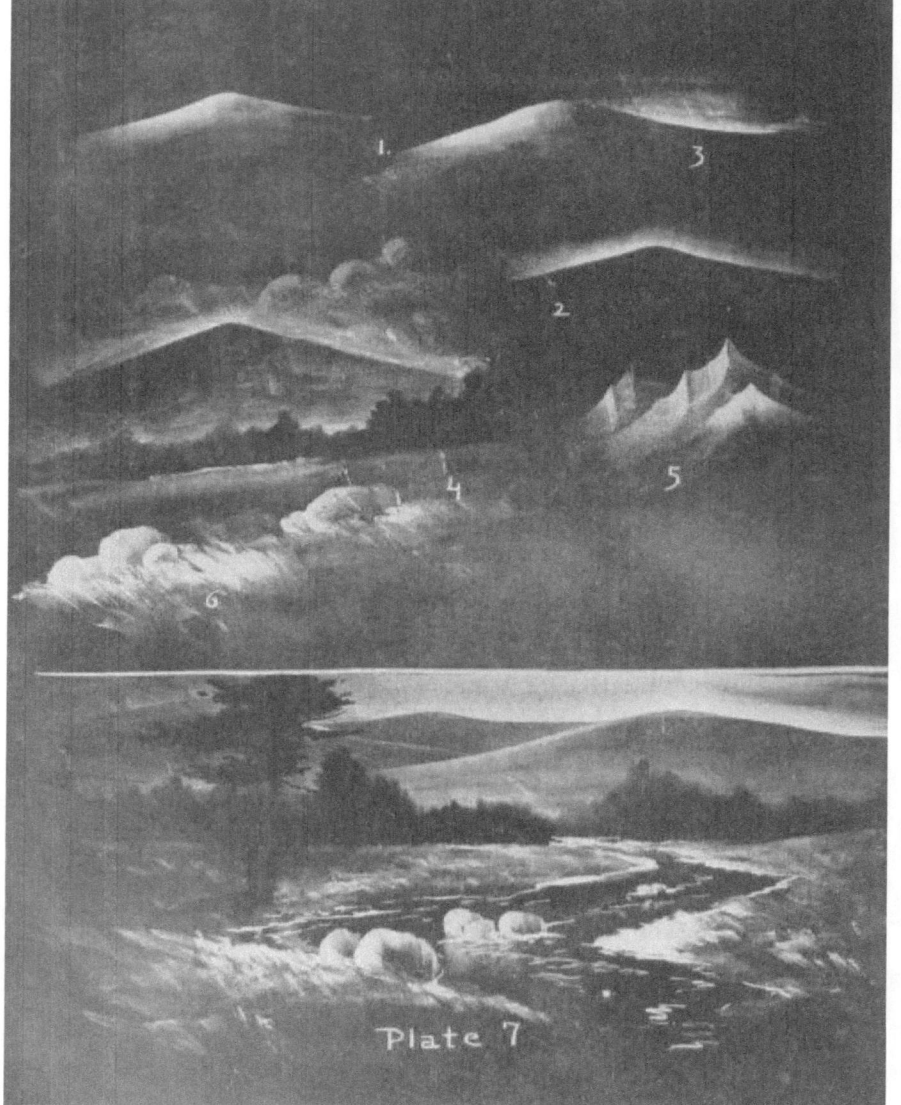

PLATE 7

In this lesson we will put to practical use such strokes as those given in the first few lessons. The sketches of this character are often valuable in the schoolroom when studying the mountains, the hillside, the river, etc., and the teacher who, with a few strokes of the chalk, can interpret to her class the thing about which they are studying, and can make an illustration which the whole class can see and appreciate, has an invaluable gift.

Experiment with the strokes given at 1, 2 and 3. As in previous lessons the side of the chalk is used, and the accent is with one end. Try to give the effect of snow, of rocks, of a bright day, or of a cloudy day, by varying the tone or pressure upon the chalk. Sometimes use the chalk for sky, leaving the board for the hills. Then reverse the stroke, letting the sky remain gray and using the chalk to represent the mountain, accenting with the upper end of the chalk. No. 3 is a combination of 1 and 2, the chalk being used in both sky and mountain. In No. 4, the eraser or a soft bit of cloth is used to take out the trees after the chalk has been applied.

In the sketch given on the lower part of the plate combine the suggestions given above. A few short, curving strokes with the usual accent at one end of the crayon will give the rocks, and the irregular horizontal and zigzag strokes already given will produce the ripples in the river, and the foreground.

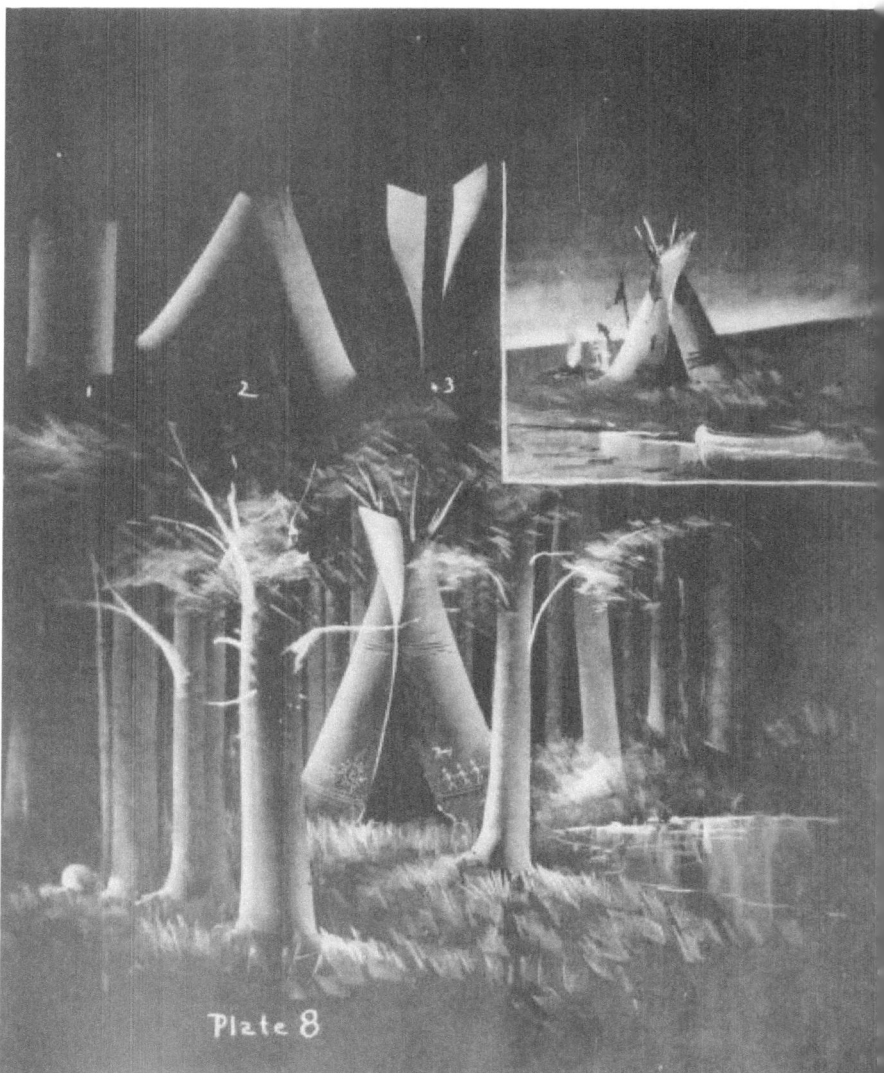

Plate 8

PLATE 8

In the exercise illustrated on the opposite page you will find combinations of the strokes already given, but they are varied somewhat in rendering these drawings. Any sketch or object to be drawn should dictate the kind of stroke to be used and the manner of handling the chalk, the pressure, accent, etc.

For the larger sketch, draw first the tree trunks as shown at No 1. Let the pressure be as gentle as possible, the chalk hardly touching the board. After these are massed in the background, erase a triangular spot for the wigwam, and with the oblique strokes 2, accented first at the left, then at the right, obtain the general form required. Stroke 3 is added at the top of the wigwam, and a bit of charcoal is used for the dark tone at the opening. Now add the decorative details.

In order to complete the sketch, use stroke 4 for the foreground. It is similar to those previously used, and is made by an irregular, up-and-down movement of the chalk.

A pond, a canoe, or other suggestive detail may be used in this sketch, and applied to the work in history, geography, language, etc.

Try the second little drawing, using similar strokes in a very simple manner.

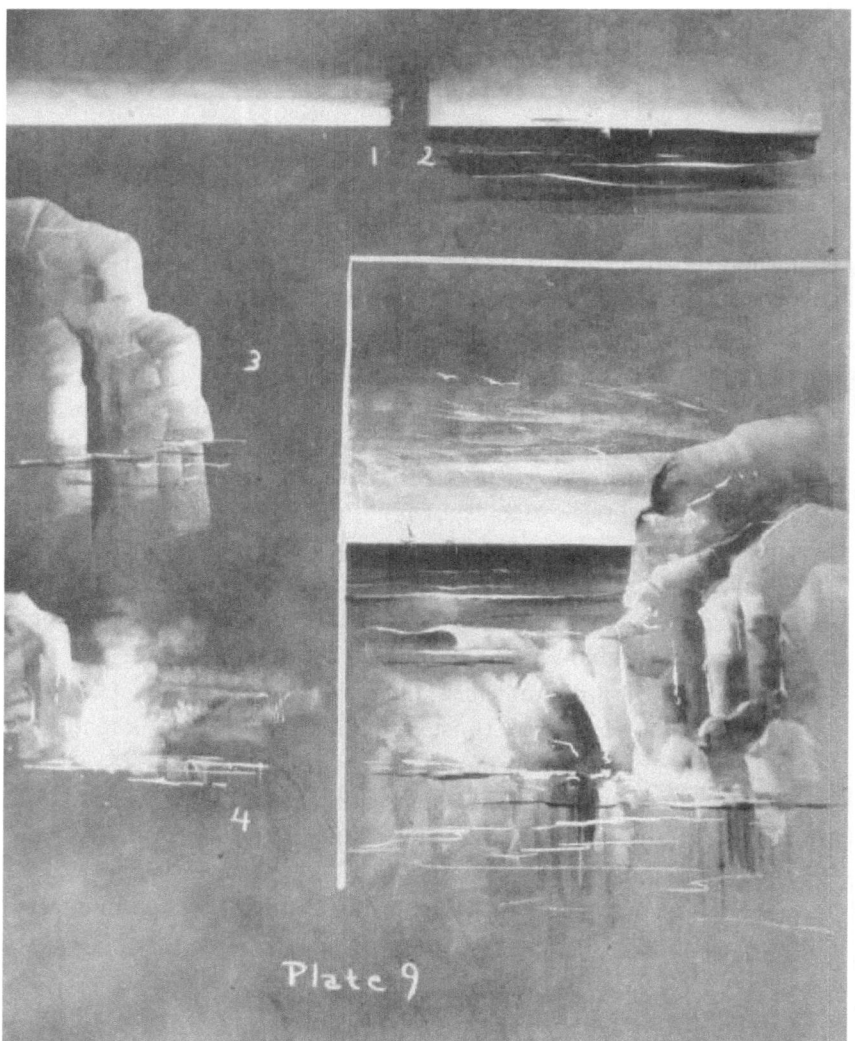

Plate 9

PLATE 9

Lesson No. 7 gave a few suggestions useful in geography and landscape work. This time we will try another type which will doubtless be found equally useful.

Stroke 1 is a horizontal stroke accented at the lower end of the chalk by a decided pressure. This will readily give a tone for the sky and a definite line for the horizon.

At No. 2, the sky is drawn in the same manner, and charcoal or black chalk is introduced for the ocean. These touches are made with the side of the chalk in irregular, wavy lines.

Spray may be represented by massing a little chalk near the rocks or beach, and by rubbing the tip of the finger or a soft bit of cloth into the body of chalk, gradually blending it into the rocks or water. See No. 4.

To obtain a sketch like that given in this lesson, first draw the horizon, then the wavy strokes for the sea. The cliffs or rocks are drawn by using strokes like those at No. 3. They are irregular strokes accented with one end of the chalk. Here again the charcoal is useful in adding crevices or shadows in the rocks. Erase spots for the boats and add details.

The effect of a beach may be produced by using the same broad stroke as in the sky, accenting with the upper end of the chalk to give the margin of the beach. Add a few ripples and pebbles, or a bit of seaweed, using the point of the chalk.

The sketch given on this plate was used as an illustration for literature.

> A heap of bare and splintery crags
> Tumbled about by lightning and frost.
> —*Lowell.*

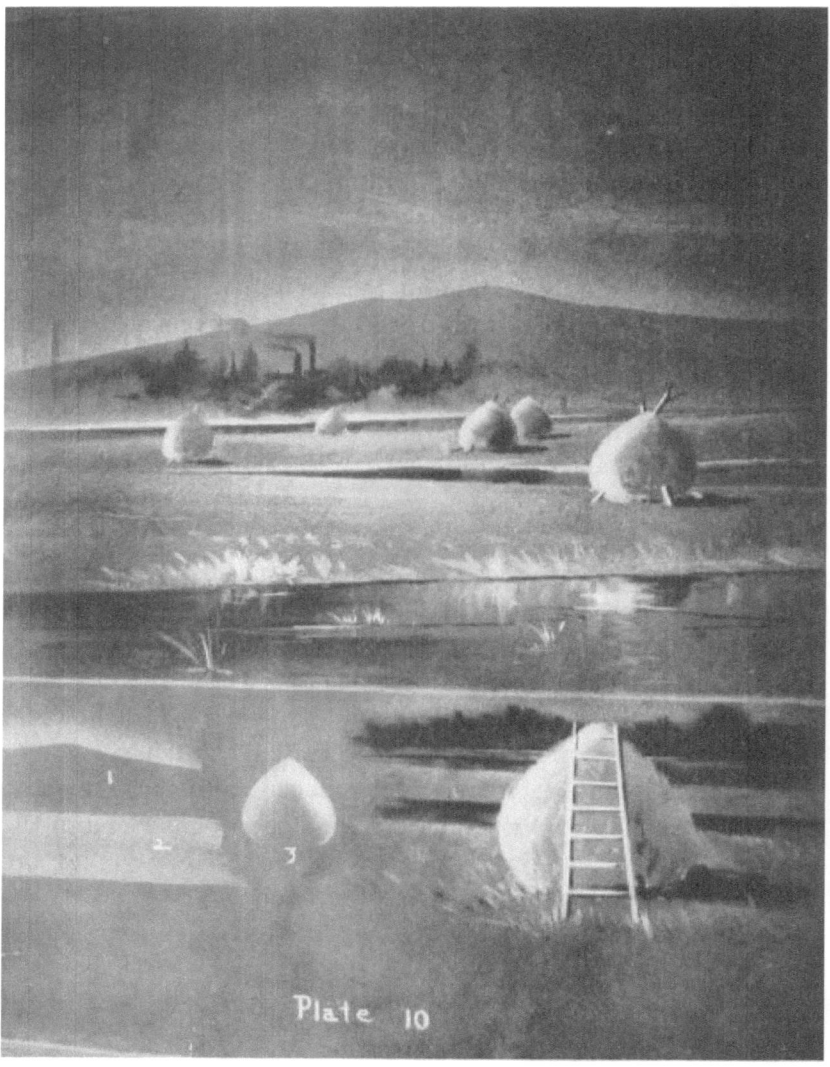

Plate 10

PLATE 10

The sketch on plate 10 was suggested for geography. It is very simple and requires only strokes already used a number of times.

The sky and hill are represented by the use of stroke 1. Place a long piece of chalk vertically, the accent at the lower end giving the outline of the hill.

The marshy land is represented by a similar stroke carried in a horizontal direction. The board is left free from chalk in the case of the hill and the water. The village in the distance is added with charcoal, and the reflections in the water with little touches of chalk or charcoal.

Erase spots for the haystacks, and use stroke 3. This is a very simple curving stroke with the side of the chalk, accenting with the left end of the crayon; then a reverse stroke, accenting with the right end of the chalk. If shadows are desired they may be added with charcoal or black crayon. Observe that the tops of all the haystacks are on a level.

The sketch with the ladder was made for primary reading. Different words were written on the different steps of the ladder and the children tried to see how high they could climb; in other words, how much of the lesson they could read. If they read all of the words they could climb to the top of the haycock.

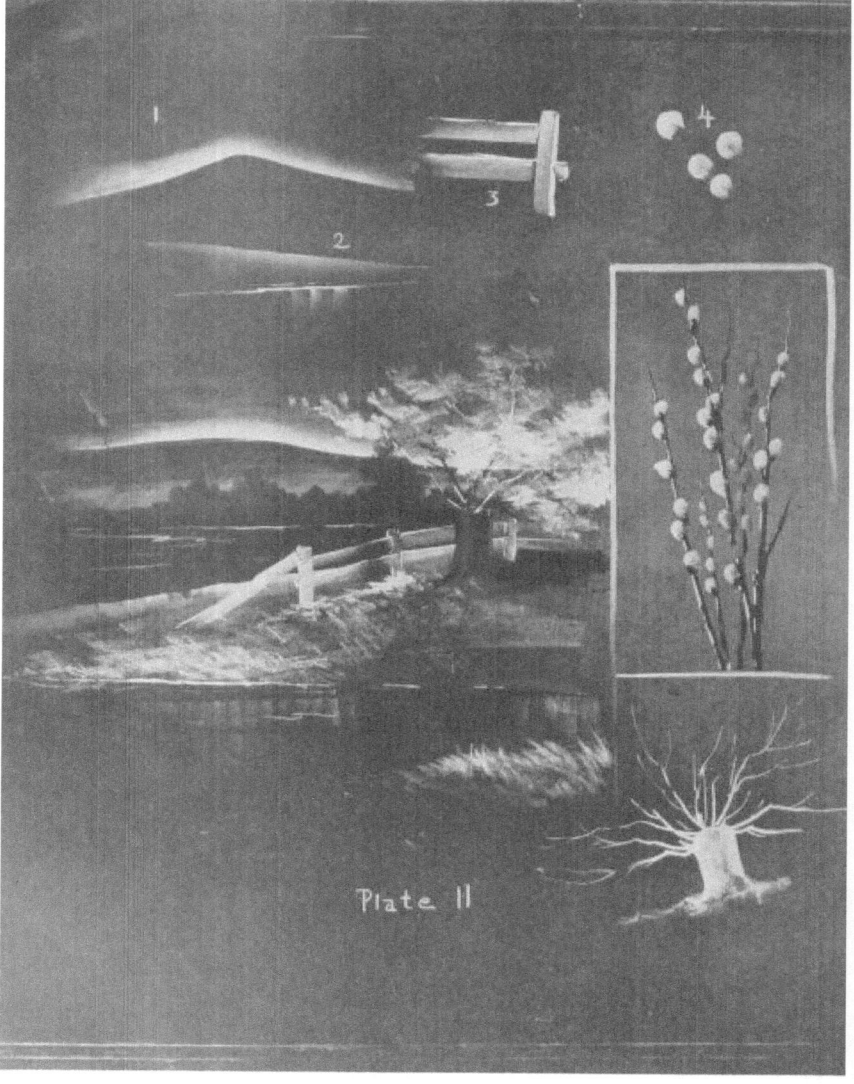

Plate II

PLATE 11

Here again are very simple strokes which require only a little practice for accomplishment.

The distance is represented as in the last plate, and the grass and meadow are done in the same manner as the marshy land on plate 10; 1 and 2 show the strokes. A few up-and-down touches with a short piece of chalk are added in the immediate foreground.

The fence is drawn by the use of the strokes given on plate 1, and shown at 3 on this plate.

After drawing the field and the fence, erase for the tree trunk and tree and add the foliage. This is done with a short piece of chalk and a quick back-and-forth movement. See plates 6, 12, and 24 for other trees and strokes. The skeleton of the tree, as shown below the drawing, may be represented first, then the foliage added.

This plate will be found useful in the early spring, as it shows the tree in winter condition, the pussy willows, and the tree in summer.

Spots 4 show the treatment of the "pussies." A very short curving stroke of the chalk is first made; then the finger is used to give the downy, soft effect. Sketch a few delicate lines for the stems, add the catkins as described above, and then finish the stems with black and white chalk.

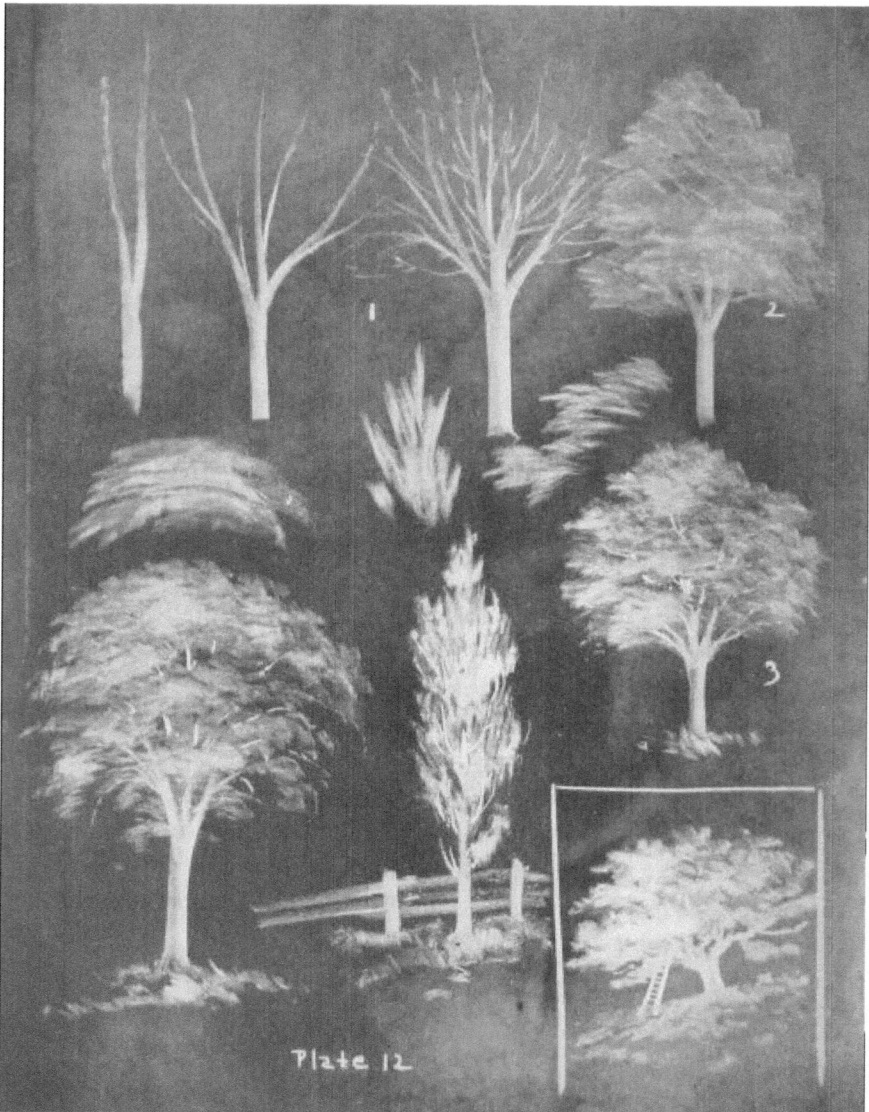

Plate 12

PLATE 12

In sketching trees, one should bear in mind the general attitude of the tree, its characteristic form and branching, and the stroke which will best produce these.

One teacher can best draw the tree by using such strokes as those at No. 1 to give the trunk and branches, and then applying the stroke for the foliage; while another teacher does better work by massing the tree, as at No. 2, and then adding trunk, branches and details. Either method is good.

The strokes above the trees show the manner of representing the foliage of these particular trees. See plates 6, 11 and 24, for other trees.

Apply either of the methods described above, using half a stick of chalk placed flat upon the board and moved rapidly in the direction suggested by the stroke. For the elm it is a curving motion; for the poplar up and down; for the pine, back and forth; for the oak or apple, an irregular and slightly slanting stroke, etc.

After the mass of the tree is drawn, accent here and there with the same stroke, and add branches and details.

When working upon a gray background or against a light tone for the sky, use black chalk or charcoal in the manner described above.

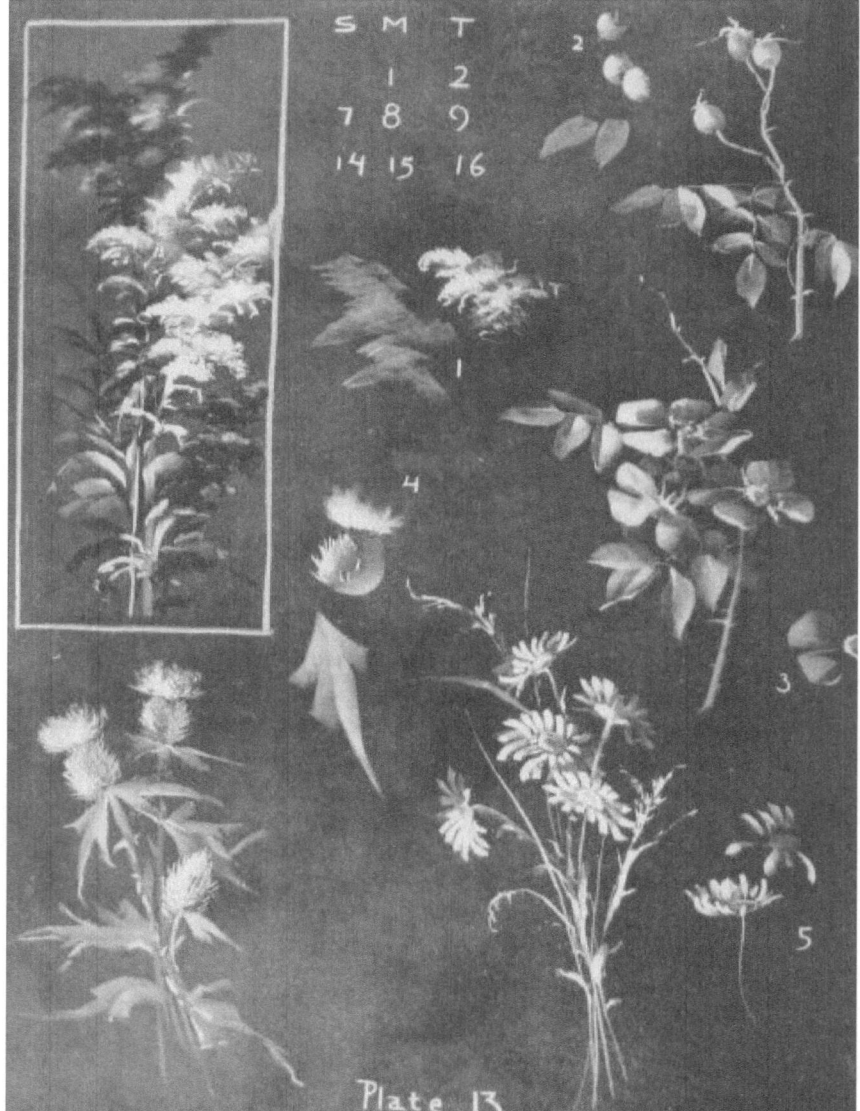

Plate 13

PLATE 13

As stated in the introduction, there have been many requests for suggestions for calendars. Whatever the month may be, draw a simple calendar large enough to be seen by the children. If a picture of some sort is desired, draw something which will be appropriate to the month and arrange it in a vertical panel at one side, or a horizontal panel above or below the calendar. The goldenrod on plate 12 will show what is meant by this arrangement.

All the strokes here given have been drawn before and are easily applied. Strokes 1 are given for the goldenrod, strokes 2 for the rose hips and leaves, 3 for the roses, 4 for the thistle, and 5 for the daisy. With a few light touches of the chalk indicate the growth and position of the specimen; then apply the strokes for drawing the surface of flowers and leaves.

In sketching the thistle the pointed details are added with the point of the chalk.

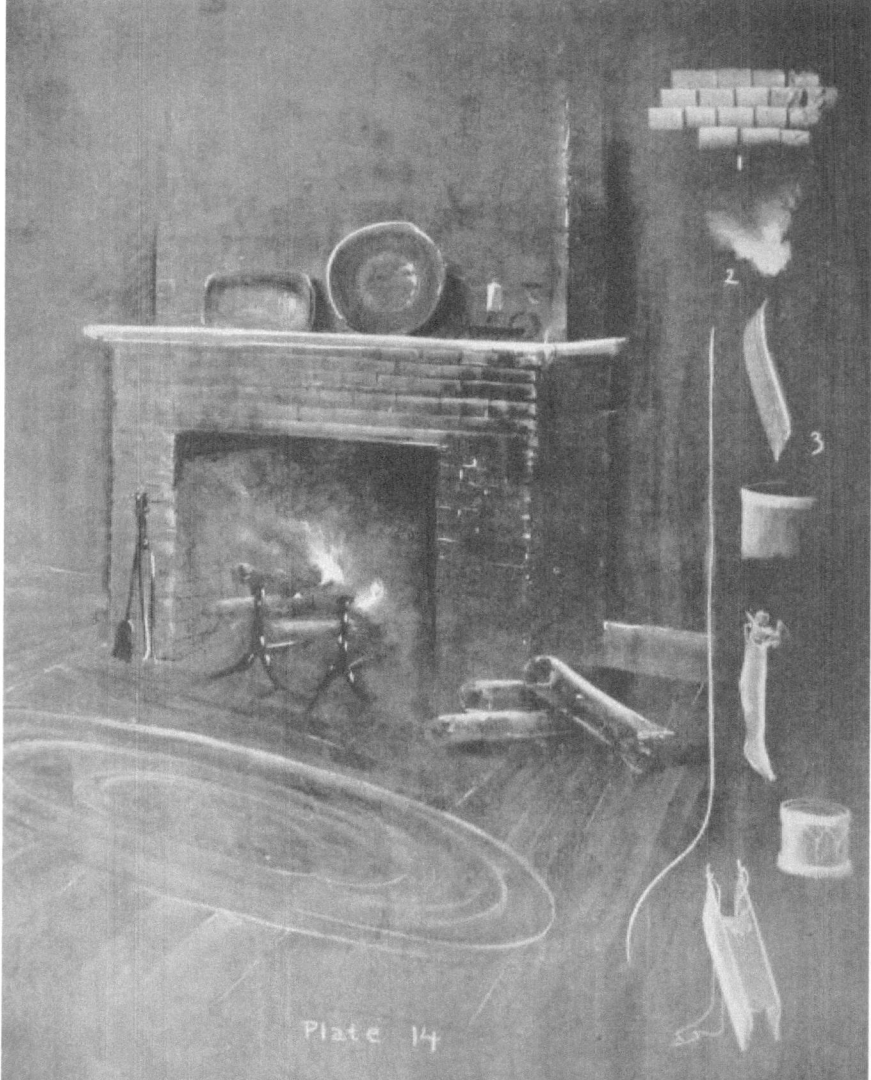

Plate 14

PLATE 14

At No. 1 is a very simple stroke made by placing a piece of chalk in a vertical position, and drawing it across the board in any desired direction, breaking it at regular intervals by lifting the chalk from the board. This stroke is useful in representing tiles, brick, stone, or any broken surface.

In this particular sketch a horizontal stroke is first made for the mantel, then the vertical strokes for the surface of the walls; then the bricks are added by the use of the strokes given at 1. Erase the space necessary for the fireplace, and add black chalk or charcoal, leaving the board where the fire is to be represented.

A few gray strokes with the side of the chalk will indicate the logs, and the use of stroke 2 will add the fire and smoke. Stroke 2 is made by massing a little white chalk, and then rubbing into it with the finger, gradually blending it into the tone of the blackboard. The details, andirons, etc., are easily added.

If this sketch is used for Christmas, add toys, sleds, stockings, or other objects suggestive of the day. They are all drawn with the side of the chalk, the direction of the stroke being dictated by the object.

The sketches in this and the following lesson may be used in work in history, or to illustrate the type of house used by the early settlers. The sketch on plate 15 is supposed to be Washington's home, and that on plate 16 is Lincoln's birthplace.

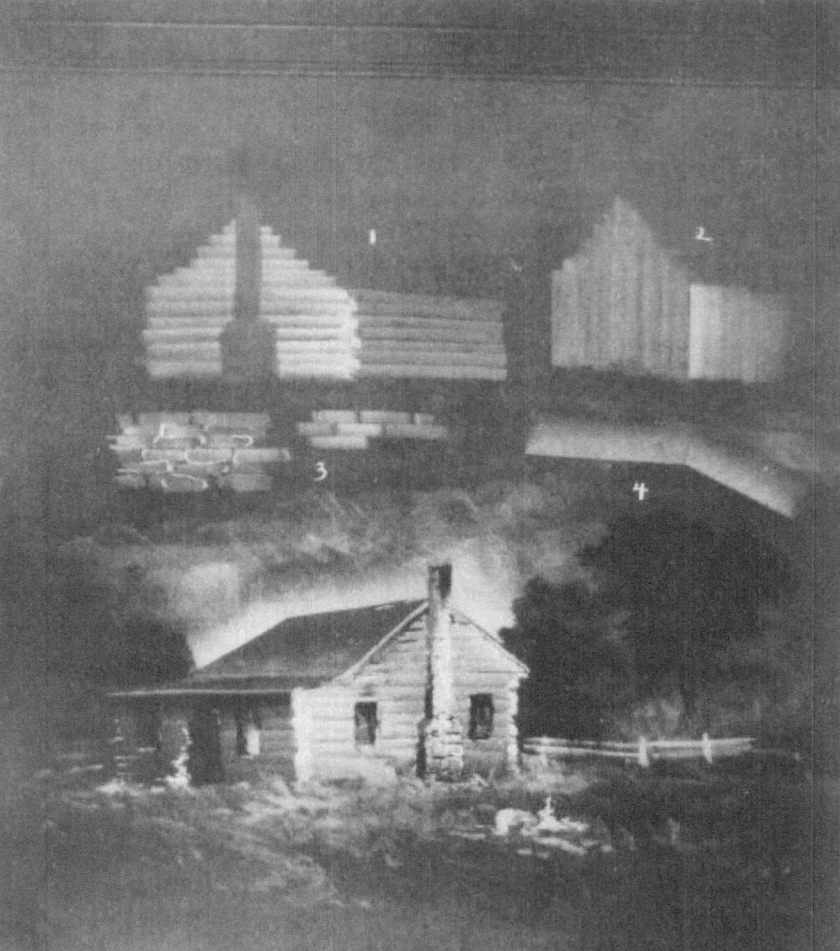

Plate 15

PLATE 15

Study the horizontal lines at No. 1. Though not like those in the sketch below, they show how any such cabin may be drawn. Try these strokes, accenting with the upper end of the chalk while making the horizontal line. Should one side of the building be lighter than the other, obtain the desired effect by varying the pressure upon the chalk.

No. 2 is made by the use of a long piece of chalk, and by keeping a smooth, even tone throughout the stroke.

Stroke 3 is made in a similar manner to that on plate 14 in the drawing of the bricks. Make it in a rather irregular fashion, and add little touches of detail with chalk or charcoal.

Stroke 4 is made with a very long piece of chalk, with strong pressure on the lower end. This will give a good tone for the sky and serve as an outline for the roof of the building.

In making this sketch, take a short piece of the chalk and use a stroke like No. 1, beginning with a very short line; and increasing the length of the strokes till the body of the house is reached and then keeping the lines of uniform length to the ground.

After the body of the building and the sky are represented, erase the logs where the chimney, windows, or door are to be drawn. Erase also whatever chalk may be upon the board where the trees are desired, and apply the irregular touches already given in drawing trees. Use chalk or charcoal, according to the tone desired in trees, windows and chimney. See stroke 3. See strokes on plate 16 and plate 12.

Plate 16 See lesson on previous
 page - Plate 14

1 2 3

PLATE 16

Study the strokes given on the previous page, plate 15, for suggestions for sketching this cabin. Those at No. 2, No. 3, and No. 4 will be found helpful.

Use stroke 4, plate 15, for the outline of the roof and the sky, and add the smooth vertical or horizontal strokes for the sides of the building. Accent here and there with the point of the chalk and add details in a similar manner, but avoid a definite outline. Let the difference in tone make whatever outline is necessary.

After erasing the spots for doors and windows, add the strong dark tones with a bit of charcoal. The details at 1 and 2 on the plate will show how these are made. No. 3 shows the treatment for the roof.

After erasing for the trees, add a little charcoal and chalk, using the strokes given in the lesson on trees, plate 12. The grass and the details in the foreground may be added last. The sketch will readily show the strokes necessary and the movement of the hand in making these strokes.

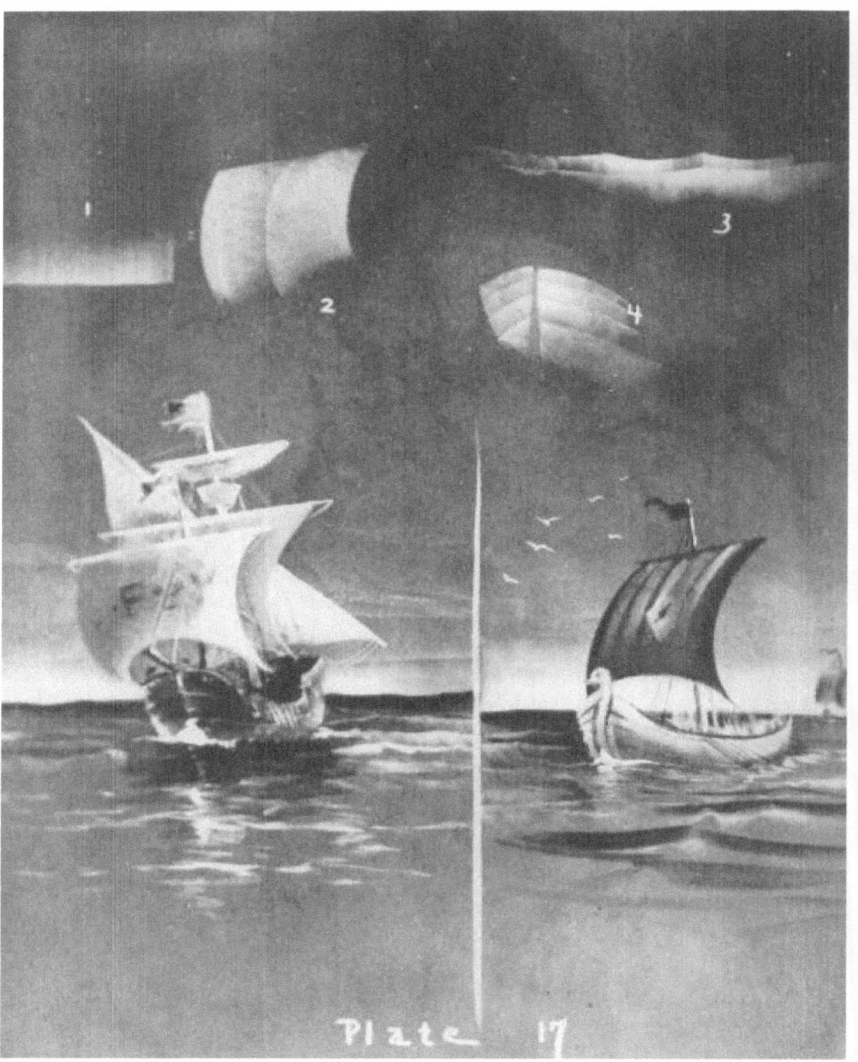

PLATE 17

Whenever I have made a sketch of this kind it has always given great pleasure to the children, and proved of more or less value in history, or in story-telling in the lower grades.

Stroke 1 illustrates the treatment for the sky and the horizon. A few soft touches with the side of the chalk will indicate clouds. Blend the white tone into the gray of the blackboard. The chalk is held vertically and drawn across the board horizontally.

Next erase a spot or two for the sails and hull of the ship, and apply stroke 2. This stroke is made by placing the chalk in an oblique position and drawing a curving stroke downward, the end of the chalk giving the outline of the sail. In the drawing at the left a graded stroke was used, the eraser making the edge of the sail at the left and the chalk at the right.

Stroke 3 is desirable in representing the ocean. It is made by placing the chalk vertically upon the board and making a long, sweeping stroke, accented with the upper end of the chalk. In these sketches charcoal was used for the dark streaks in the water.

In drawing the hull of the ship, try stroke 4, using a short piece of chalk or charcoal. The chalk is placed vertically and a curving stroke is used with no particular accent. Add details with touches of chalk or charcoal.

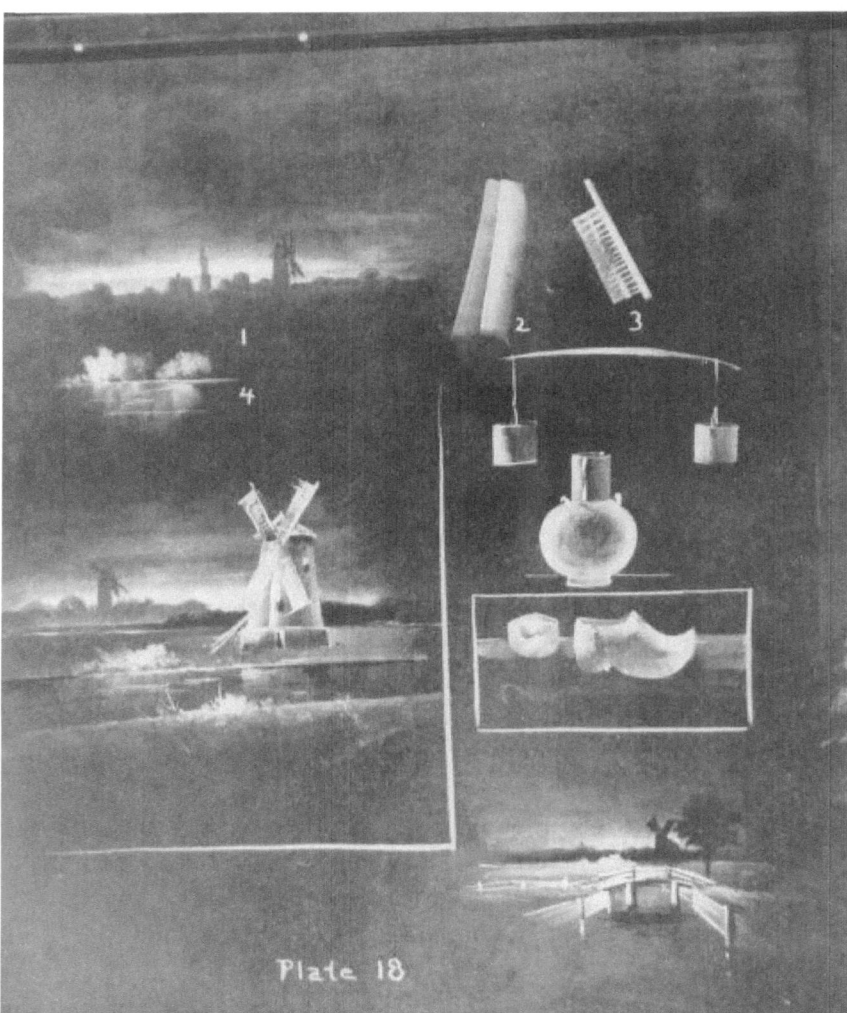

Plate 18

PLATE 18

On plate 18 are suggestions for the month of March, or for geography, history, or occupations and habits of the people.

Apply a few delicate, horizontal and curving strokes to the board; then with a soft piece of cloth erase for the distance, as at No. 1. Use stroke 2 for the sides of the windmill, stroke 3 for the wings, and touches of charcoal for the windows.

Stroke 5, plate 3, will help in representing the foreground. Use the chalk very delicately, accenting here and there with stronger touches, and a vertical stroke now and then for the reflections in the water — stroke 4.

The strokes illustrated on plates 2, 3, and 5 will be useful in sketching the shores and other objects. Remember to allow the pressure upon the chalk to indicate the outlines of objects, and never to add definite marks with the point excepting for necessary details or high lights.

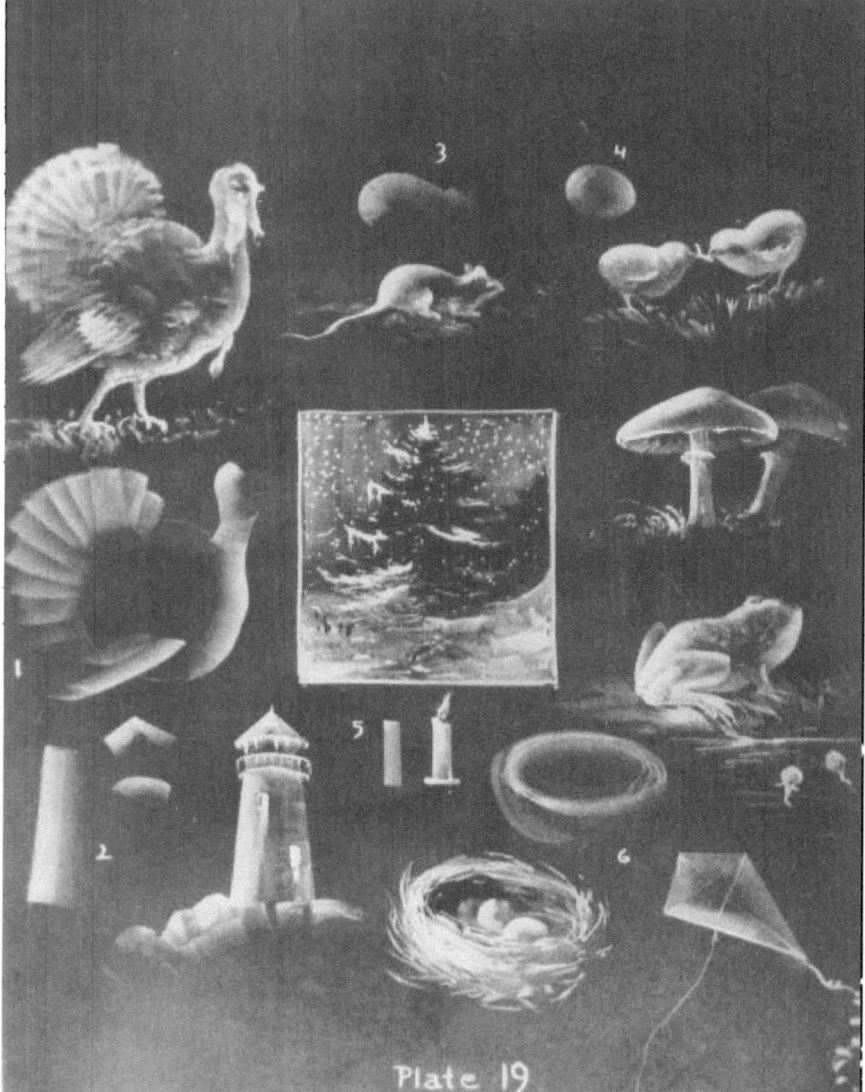

Plate 19

PLATE 19

This plate was planned as a review lesson, as well as to give illustrations which teachers might use for a great variety of purposes. All these strokes have been given before and are easily applied.

For the turkey, sketch lightly a circle; then with the side of the chalk add broad, gray strokes. See No. 1. After this is done, add short touches with the side of the chalk, for the wings, legs, feathers, etc.

Stroke 2 was given on plate 2, and, with the addition of the little slanting and curving strokes here given, will produce the lighthouse. This sketch will perhaps be useful in connection with plate 9, in teaching the seacoast.

Strokes 3 and 4 are similar to those given on plate 5. They are made by the use of curving strokes with the side of the chalk, the accent being upon the end forming the outline. This stroke is frequently used, the object to be drawn dictating the direction of the stroke. Apply these strokes in drawing the rat, the chickens, the mushrooms and the frog.

In the tree sketch, a background of gray is first drawn with the side of the chalk; then the strokes given on plate 6 are applied with charcoal, and the snowflakes added with strong touches of white chalk. If the candles are desired, omit the snow and use tiny strokes like those at 5.

No. 6 is desirable in representing the nest. After 6 is drawn, add stroke 4 for the eggs and finish the nest by using strong touches with the point of the chalk.

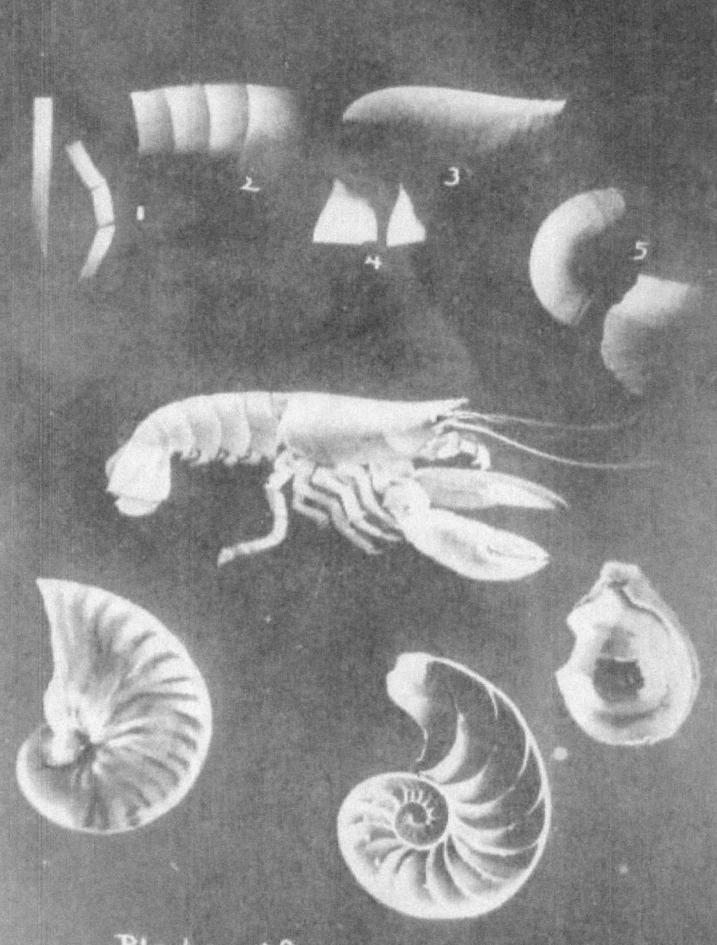

Plate 20

PLATE 20

The strokes on plate 20 are so well defined that it hardly seems necessary to describe them. For 1 a short piece of chalk is used, the side of the chalk giving the width of the line. At 2 the stroke is similar, the accent being at one end of the chalk. At 3 the stroke is slightly curving, the chalk being placed vertically, and the accent being upon the upper end of the chalk. No. 4 is drawn by placing the chalk vertically upon the board, drawing it downward very quickly and twisting it to the horizontal position. Apply these strokes in sketching the lobster. First use stroke 3, then touches like 2; afterward strokes 1 and 4 for details.

No. 5 indicates the strokes first used in sketching the shells. In drawing the outside of the nautilus, use a long piece of chalk and with a curving stroke accented with the end, form the outline. With strokes similar to those at 2, sketch the light streaks in the shell, and add dark details with charcoal. Use the tip of the finger in softening the tones here and there.

In drawing the section, sketch first the spiral curve, then the blended strokes connecting the outer with the inner curves of the spiral, and add charcoal for shadows.

The oyster shell is drawn by the use of the lower stroke at No. 5. Make the stroke, accenting a little at the left end of the chalk; then reverse the stroke, accenting with the right end, and add details with chalk and charcoal.

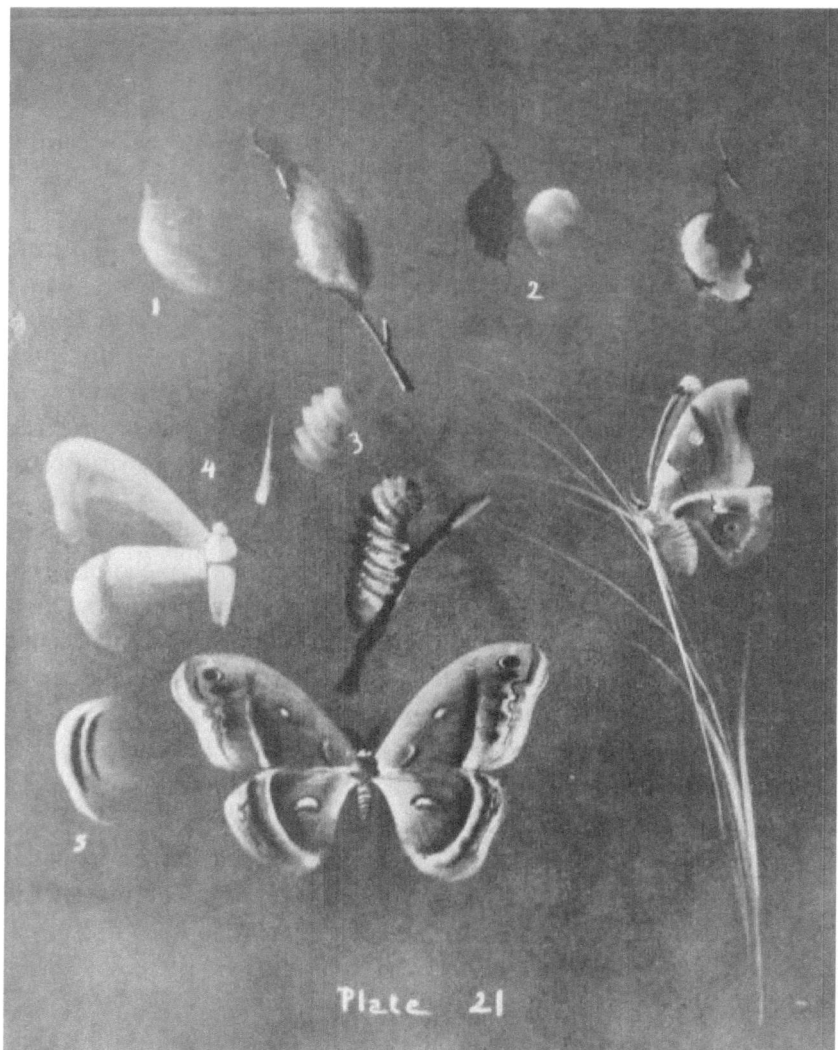

Plate 21

PLATE 21

The strokes and touches used upon plate 21 are more delicate than any previously given, though similar in character. No. 1 is drawn with the side of the chalk, the accent being with the left end. Allow the hand to tremble a bit and the texture desired is more readily obtained. Stroke 2 is produced in the same manner. After these are drawn add the shades, stems, and leaf with charcoal, and high lights with touches of white chalk.

Stroke 3 is exactly like that at No. 2, plate 20, though drawn with a much smaller piece of chalk. A series of these strokes, with the addition of touches with the charcoal and point of the chalk, as indicated in the sketch, will produce the caterpillar.

Strokes 4 and 5 are valuable in sketching a butterfly or moth. They are gray strokes with the side of the chalk, the pressure being upon the end forming the outline. In work of this kind study nature very carefully, as no sketch or copy can do what nature can for the teacher. After the general form of the butterfly is drawn with these light gray strokes, add the details, using touches of chalk or charcoal, and occasionally blending them with the tip of the finger.

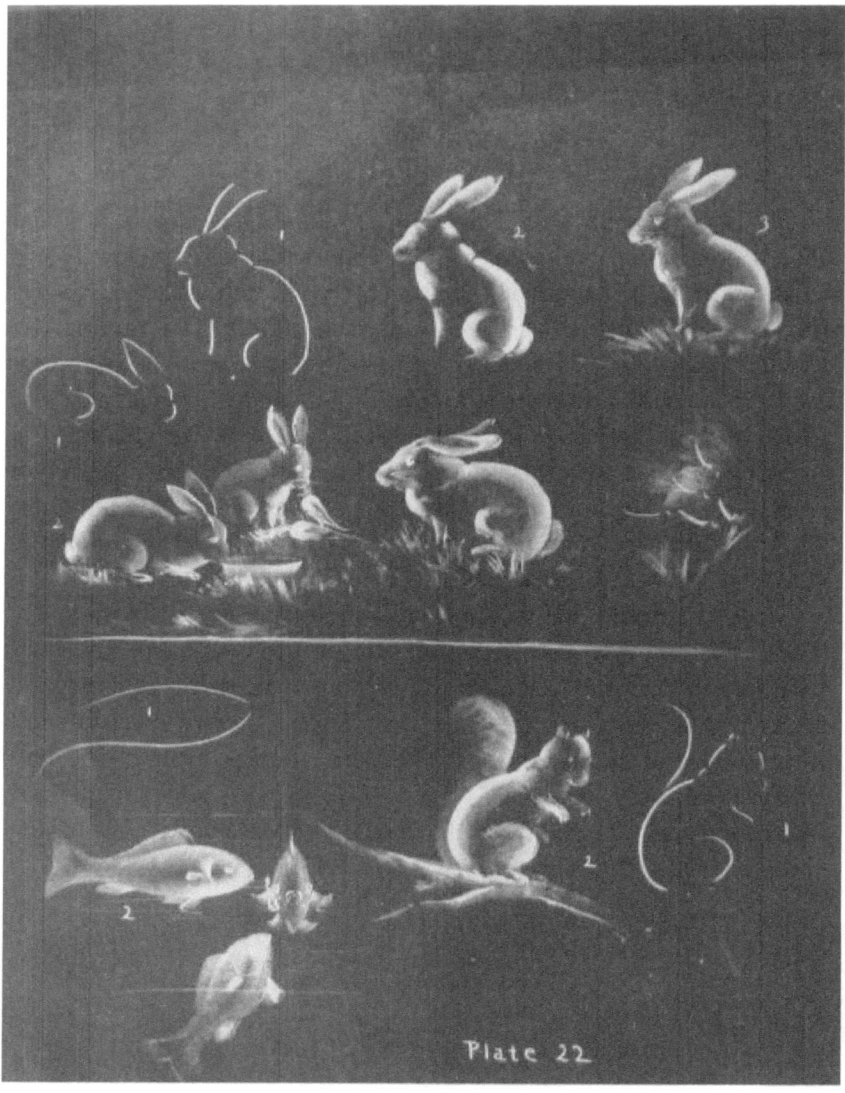

Plate 22

PLATE 22

A very few lines will often indicate the pose or action of an animal. Try lines similar to those at 1 ; study other animals and try a few characteristic lines. See No. 1 for the squirrel and for the fish.

After practicing the pose, try 2 without sketching the lines with the point of the chalk, but by using the side, as in previous sketches. To finish the sketch add the few details necessary, as shown in the other drawings.

The strokes used in these sketches are given on several other plates. They are produced by using the side of about two-thirds of a stick of chalk, and by accenting or letting the pressure be greatest at the end of the chalk which is to form the outline. This type of stroke is perhaps most evident where the pressure was upon the left end of the chalk, as in the squirrel's back.

See also stroke 4, plate 3, and strokes upon plate 5.

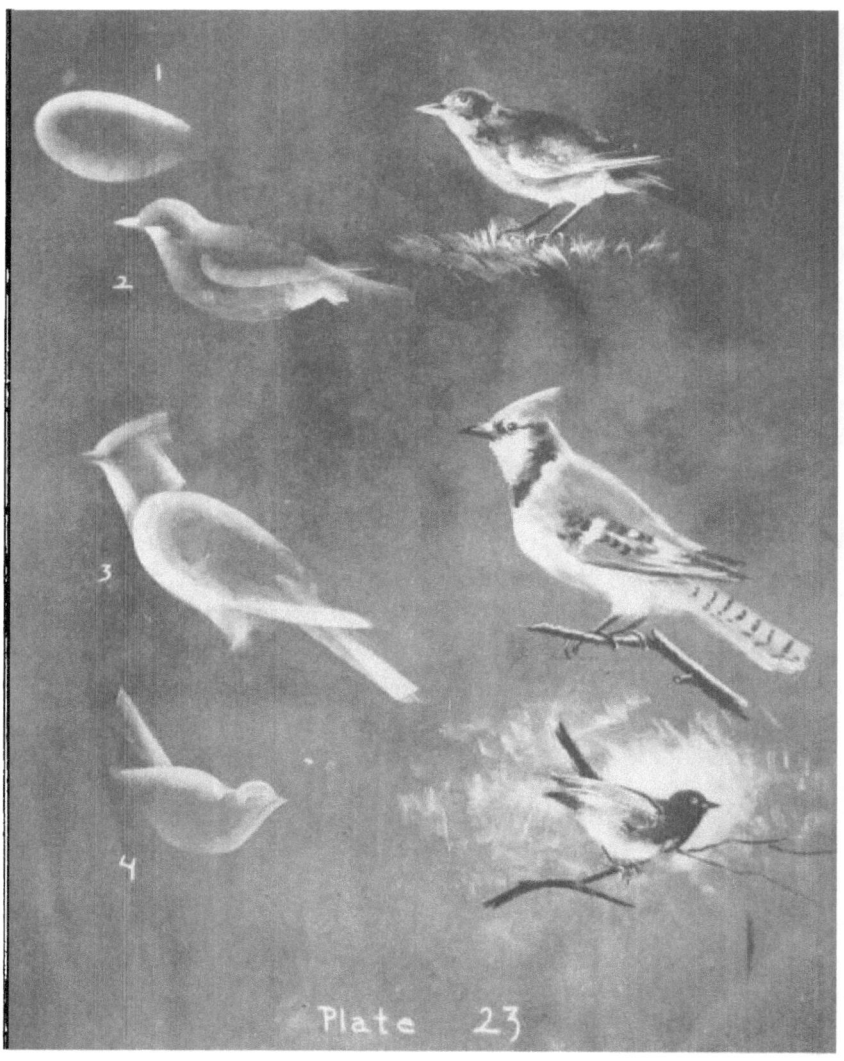

Plate 23

PLATE 23

The strokes used in the birds are exactly like those described in the previous lesson.

Sketch first an egg shape, No. 1, using half or two-thirds of a stick of chalk, and pressing a bit upon the outer end, letting the stroke blend into the board.

Add to this a few blended strokes representing the form and position of head, tail and wing. The sketches at 2, 3 and 4 indicate upon which end of the chalk the pressure should come. Be careful to keep the delicate gray or middle tones.

After such drawings as those at 2, 3 and 4 are made, then add the characteristic details with the chalk and charcoal. It will be seen by studying these finished drawings that only a few touches are necessary to complete the sketches.

In order to obtain a contrast between the background and the head of the bird in the lower sketch, a little chalk was massed upon the board as a background. See plate 12.

Plate 24

PLATE 24

These sketches are drawn as illustrations for literature, but would be quite as useful in some other studies.

The strokes at 1, 2 and 3 are those used in the tree sketch; 1 is obtained by two strokes of the chalk, placed vertically upon the board and accented by a pressure upon the lower end. These strokes give the sky and the hills in the distance. The use of the eraser and a few blended strokes like those at 2 will help in sketching the tree trunks. See plate 2. After these are done, add stroke 3, and with it mass the foliage. See suggestions on plate 12. The point of land in the distance and a few of the branches are added with charcoal.

Study the lesson on plate 23 before sketching the sparrow. Stroke 4 is made with a single broad mark of charcoal, and the addition of tiny touches with the chalk. The branch is drawn in a similar manner, and the background is added by a few soft and delicate touches with the side of the chalk.

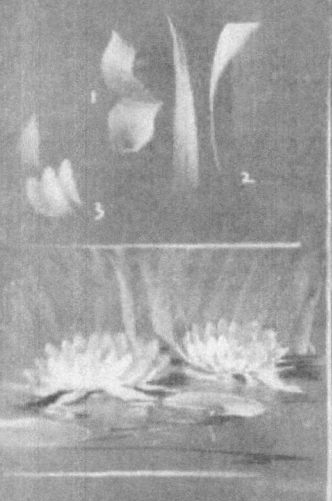
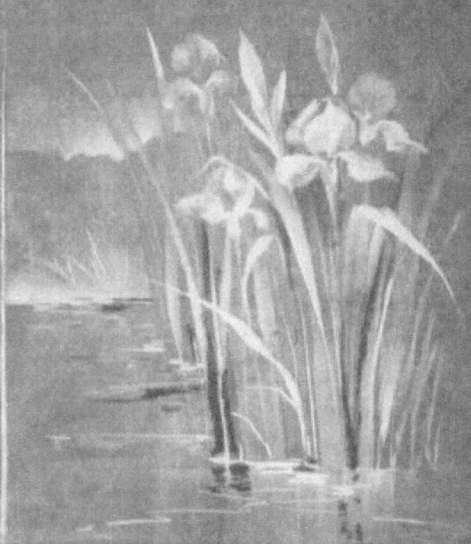

Beautiful lily, dwelling by still rivers,
 Or solitary mere,
Or where the sluggish meadow-brook delivers
 Its waters to the weir ——
 Longfellow

Plate 25

PLATE 25

This plate was used as an illustration for Longfellow's "Flower-de-luce." The pond-lily may be used in nature study or as an illustration for some poem.

The strokes necessary or useful in drawing these bits are shown at No. 1, No. 2 and No. 3. At No. 1 the chalk is placed in an oblique position, drawn gradually downward, and at the same time twisted to the horizontal position at the middle of the stroke. Try this stroke in a great variety of positions. The spots produced will be found useful in much of the flower and leaf drawing. Apply these in the fleur-de-lis.

The strokes at 2 for the leaves were given and described on plate 4, and may be appropriated wherever reeds or grasses are to be drawn.

Stroke 3 is simple, yet often found troublesome by pupils. Place the chalk in a vertical position, draw it quickly downward, twisting it to a nearly horizontal position. Let the accent be at the upper end of the stroke. Try a number of these strokes, letting them meet at the centre of the flower. In making the drawing of the pond-lily, accent the nearest petals.

The reflection in the water, and the reeds in the background are obtained by delicate vertical strokes, crossed in the water by occasional horizontal touches. Use simple curving strokes for the lily pads.

"This castle hath a pleasant seat."

———our castle's strength
Will laugh a siege to scorn.
—Shakespeare.

Plate 26

PLATE 26

Here is given another literature illustration, which is drawn with such strokes as those indicated in the upper part of the plate.

Stroke 1 has been described many times already. After this is drawn indicate the distance by the use of a few touches with charcoal, and the water with a delicate line or two of chalk. Let the strokes be horizontal.

The rocks are represented with such strokes as No. 3. See also plate 9, stroke 3. Accent here and there for the light touches, and add bits of charcoal for the dark.

Stroke 2 is drawn by placing the chalk in a vertical position, and drawing it in the desired direction with a rather irregular or uneven stroke. See stroke 3, plate 15. When the strong, bright tones are desired, accent with the chalk, and when the gray tones are necessary, hardly touch the board. The windows are added with strong strokes of charcoal.

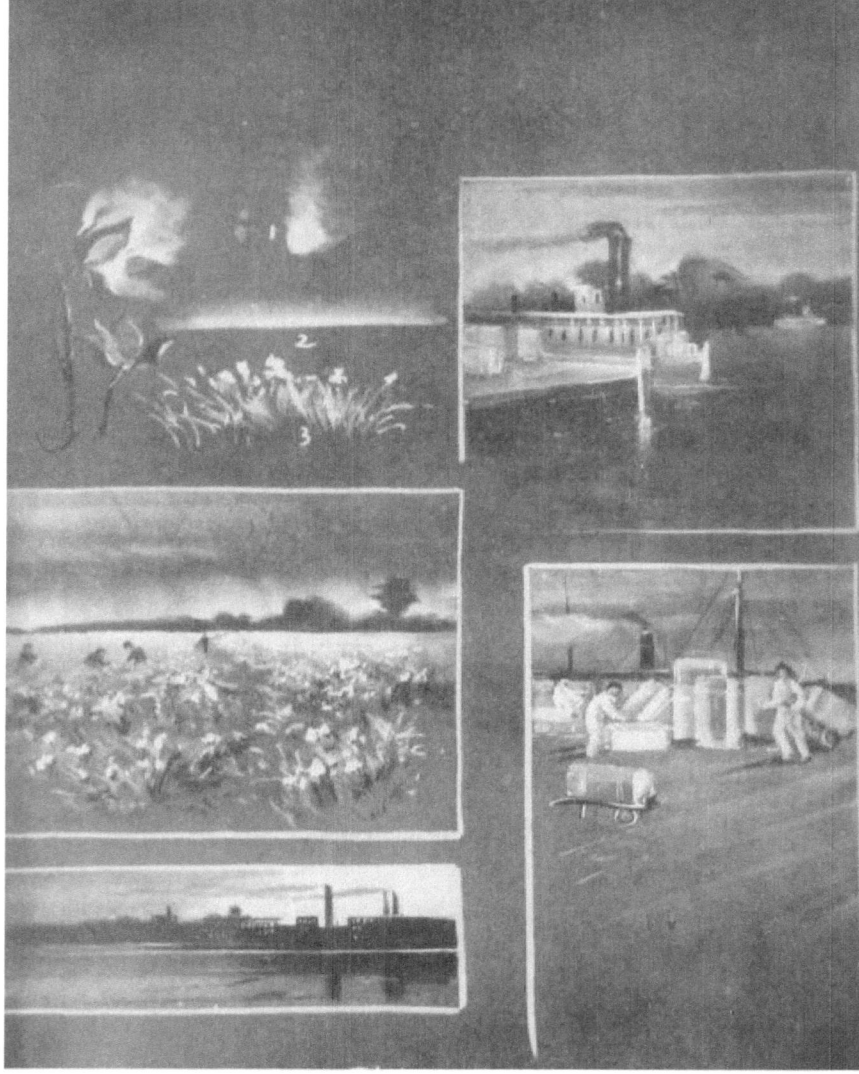

PLATE 27

This plate was planned especially for arithmetic lessons, as it shows in the sketches the various processes through which the cotton passes before reaching the retailer, thus suggesting a number of practical problems. It may be used quite as well in geography, history, and nature study.

Spot 1 is produced by massing a bit of chalk and then rubbing it into the desired shape by the use of the finger tip. The pod is drawn with a short stick of charcoal, used in the same manner as the chalk.

No. 2 shows the stroke for the sky and horizon, and has already been described in many other lessons.

To produce the effect shown at No. 3 use the side of a short piece of chalk, and with a rather irregular stroke draw the twigs and stems. Accent the spots for the cotton balls.

In the other small sketches the strokes are so evident that they hardly need description. A white, smooth sky, erased where the mills and chimneys appear, will produce the effect in the lowest drawing. A little charcoal may be added for the darkest tones, a stroke of the eraser for the smoke, and little touches of chalk for the windows.

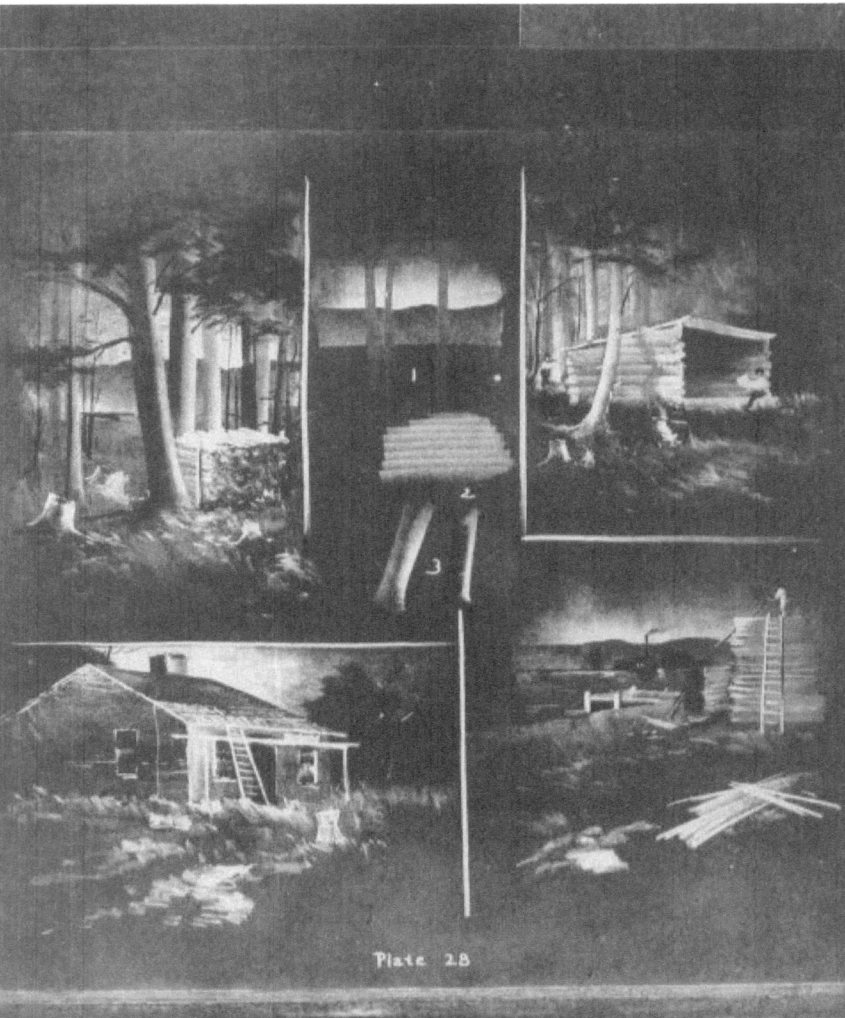

Plate 28

PLATE 28

These sketches were also suggested for problems in arithmetic. The problems relate to lumbering, measurement, and commission.

No. 1 illustrates the beginning of a forest sketch. With a single stroke of the chalk, accented at the lower end, draw the sky. With a second more delicate stroke show the distance; then with a few quick, nearly vertical strokes with the eraser show the positions of the trees. Later with chalk or charcoal and the use of such strokes as those given on plate 2, and at No. 3 on this plate, add the shading in the tree trunks.

No. 2 shows the strokes useful in drawing the camp, the wood pile, or the lumber. These have already been given in such sketches as those on plate 15.

The sketch of the house in the original had the dimensions marked upon it, and the pupils were to find the shingles required for the roof, the clapboards for the walls, etc.

Before trying this sketch, study plates 15 and 16 for strokes and details.

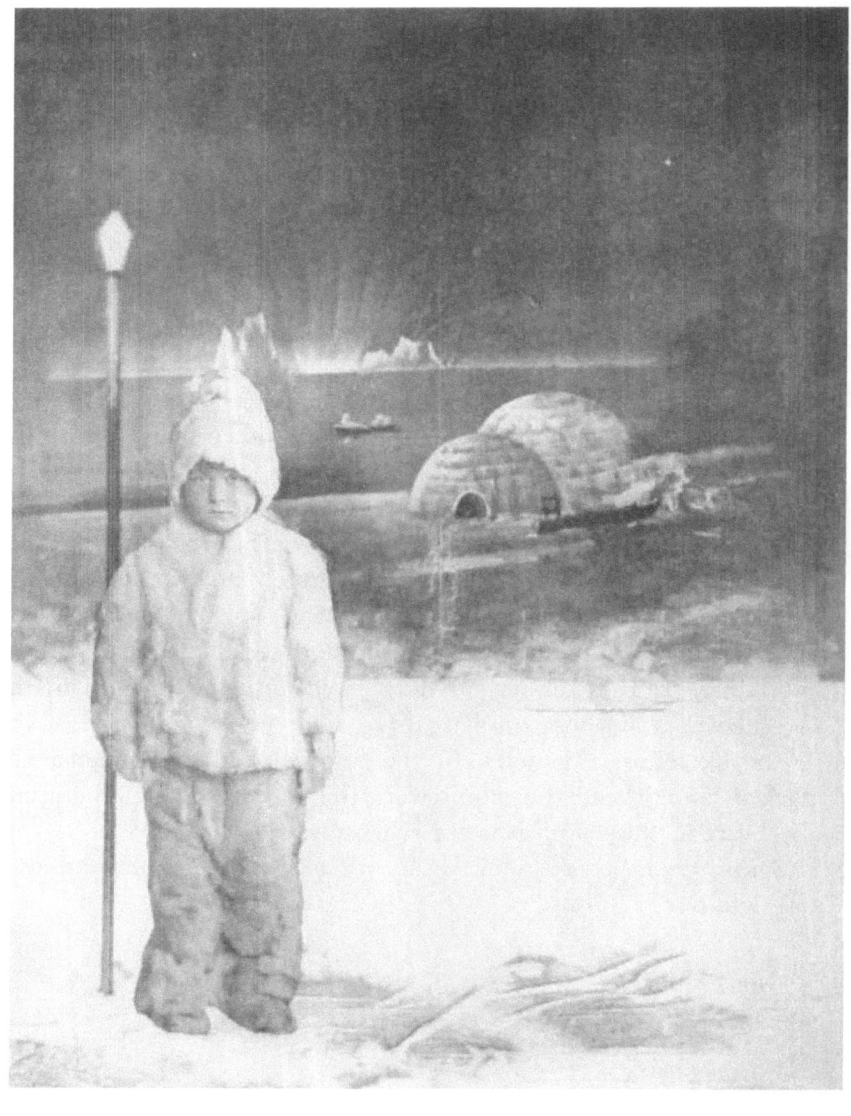

PLATE 29

The accompanying plate was taken from a lesson in a first grade. The little boy was dressed in an impromptu costume of cotton batting, and the background hastily sketched by the teacher.

The horizon was drawn as on plate 9; then a few soft oblique strokes were added to the sky. The shore was drawn with irregular back-and-forth strokes, as in many of the previous sketches, and a sheet was tacked to the board in order to obtain the white foreground.

An almost vertical stroke accented with the end of the chalk was used in drawing the icebergs, and a few strokes of charcoal were added.

The huts were drawn with a curving stroke accented with the upper end of the chalk, and they were finished by applying stroke 2, plate 3, and adding a few details with the point of the chalk.

Any teacher can easily arrange such backgrounds and costumes with the simplest material at hand, and in this manner add essentially to the interest and value of a lesson. A Japanese Day, An Indian Entertainment, A Soldiers' Camp Ground, A Lumber Camp, and many others, are easily arranged.

www.ingramcontent.com/pod-product-compliance
Lightning Source LLC
Chambersburg PA
CBHW020708180526
45163CB00008B/2983